MW00617364

STORIES OF
SPRINGFIELD

STORIES OF
SPRINGFIELD
LIFE IN LINCOLN'S TOWN

TARA McCLELLAN McANDREW

Charleston · London
THE
History
PRESS

Published by The History Press
Charleston, SC 29403
www.historypress.net

Copyright © 2010 by Tara McClellan McAndrew
All rights reserved

Cover images: Top photo is Springfield's Old State Capitol as it looks today. This was the first statehouse built in Springfield. Abraham Lincoln served in it as a legislator. *Photo by David Blanchette. Courtesy of the Illinois Historic Preservation Agency.* Bottom photo is a horse-drawn trolley that took Springfieldians to a popular beer garden just past the city's western limits in the late 1800s. *Courtesy of the Sangamon Valley Collection, Lincoln Library, Springfield, Illinois.*

First published 2010

Manufactured in the United States

ISBN 978.1.59629.932.0

McAndrew, Tara McClellan.
Stories of Springfield : life in Lincoln's town / Tara McClellan McAndrew.
p. cm.
Includes bibliographical references.
ISBN 978-1-59629-932-0
1. Springfield (Ill.)--History. 2. Springfield (Ill.)--Social life and customs. 3. Lincoln, Abraham, 1809-1865--Homes and haunts--Illinois--Springfield. I. Title.
F549.S7M43 2010
977.3'56--dc22
2010015340

Notice: The information in this book is true and complete to the best of our knowledge. It is offered without guarantee on the part of the author or The History Press. The author and The History Press disclaim all liability in connection with the use of this book.

All rights reserved. No part of this book may be reproduced or transmitted in any form whatsoever without prior written permission from the publisher except in the case of brief quotations embodied in critical articles and reviews.

To my parents, Russ and Diane McClellan, for your unending support regardless of the project. Thank you.

CONTENTS

Foreword, by Curtis Mann 9

Acknowledgements 11

Part I. Uniquely Springfield

The Grave Matters of John Krous 13

Springfield by Any Other Name 15

Morality Trumps Cholera 17

Before Corn Dogs and Taffy 19

The Land of Inventors 22

A Poet's Mysterious Death 25

Cleopatra's Springfield Roots 28

Springfield Put the Arson in Arsenal 28

Part II. Behaving Badly

Springfield's First Con 35

The Pole Wars 37

Blow-by-Blow Journalism 39

A Capitol Affair 41

Was Springfield Hell? 44

All the News that's Fit to Print 48

CONTENTS

Part III. The Lincolns

Lincoln and the Thespians 51
The Lincoln Controversy that Wasn't 53
The President Is Shot 56
Springfield's Long Goodbye 59
The Booth Brothers and the Lincolns 63
The Bloodstained Dress 65
The Strange Tale of Lincoln's Son, the Secret
 Service and Stupid Criminals 68
Mary Lincoln Comes Home 73
The First Abraham Lincoln Presidential Museum 76

Part IV. African Americans

Early African Americans 81
Springfield's Underground Railroad 83
Billy the Barber 89
"No Rope to Hang Him" 92

Part V. Suffering

The Millerites' Disappointments 99
Camp Misery 101
Springfield Suffers the Suffragists 103
Coming to the Land of Lincoln 105

Part VI. Miscellany: From Baseball to UFOs

Town Ball Hits Home 111
Hot Air Over Illinois 114
Did Politics Save New Salem? 116
Ode to a Legislative Husband 118

Bibliography 121
About the Author 127

FOREWORD

Tara McClellan McAndrew's book about the history of Springfield covers a wide range of subject matter, ranging from the city's light-hearted side to its dark past. Some of the articles provide new facts or interpretations of familiar stories. Others unravel the truth behind a common myth or bring unknown stories to light.

This book combines the best of her local history columns with new stories, and I'm sure it will become recognized for its valuable contribution to Springfield's long list of history books.

From articles about Abraham Lincoln and his wife to stories about the 1908 race riots, I know readers will enjoy the many fascinating stories found within these pages.

Curtis Mann
Springfield City Historian

Acknowledgements

To my mom, who said, "I know you're going to write a book someday." In my mind, it was like saying, "I know you're going to visit Pluto someday." Regardless of your age, listen to your mother.

To my husband and son, Bill and Connor McAndrew, for their love and support. XO.

To my friends and fellow writers Julie Kaiser and Mary Byers for advice, assistance and friendship.

To my friend and former *State Journal-Register* editor Erin Orr for helping me with edits and, most importantly, for believing that I could write a local history column, which led to this book. You helped start all of this.

To the terrific librarians at the Sangamon Valley Collection at Lincoln Library for a great deal of research assistance year after year.

To City Historian Curtis Mann for writing my book's foreword and sharing his knowledge of book publication and promotion.

To the always helpful staff, historians and director of the Abraham Lincoln Presidential Library (ALPL).

To my History Press editor Ben Gibson, who approached me with the idea for this book.

To the historians and others quoted in these stories who were generous with their time and information.

ACKNOWLEDGEMENTS

To my *Illinois Times* former editor, Roland Klose, and current editor, Bud Farrar, both of whom believed in the importance of a local history column.

To Springfield mayor Tim Davlin, his assistant Jim Donelan and his aide Susan Shelton for their assistance in trying to reach Dame Elizabeth.

To Val and DeeAnn Watt, for cheering me on.

Part I

Uniquely Springfield

The Grave Matters of John Krous

Being a saloon keeper in Springfield wasn't easy in 1874. According to newspapers from that year, a "great temperance crusade" was sweeping the city. Women would barge into local saloons and lobby the owners to close.

Maybe that's one reason why John G. Krous moved his saloon out of town. By 1875, he had relocated to the beautiful suburb of West Springfield, which is currently the west-central part of the city. (His former property is now a residential area located a couple blocks southwest of Sacred Heart Griffin High School.)

In those ten tree-filled acres, the German-born Krous built his home and a beer garden, which became known as Krous Park. The park had tables, winding walks, a bandstand and a big dance pavilion, according to a January 25, 1951 *Illinois State Journal* article.

"Krous' park was the biggest thrill in town," stated a May 17, 1942 *Illinois State Journal* article. "[It was] a gay rendezvous for a Sunday afternoon where the ladies dressed in the fashion of the '80s, cast coquettish glances at the elegant mustached gentlemen garbed in those fetching styles of that period, embellished with the popular walking stick."

"John was German Lutheran," says his great-great-niece, Teri Spraggins of Carson City, Nevada. "And the beer garden was quite popular with the

German community at that time. Sunday, although a day of worship for them, was also their day of rest and relaxation."

Stu Fliege, archivist and historian for Springfield's Trinity Lutheran Church, says the church used to hold picnics at Krous Park in the late 1800s.

"The fact that plenty of iced beer was available on the hot summer days served to make the park all the more popular," noted the 1942 *Journal* article.

Not much documentation can be found today about Krous Park, and details about John Krous's life are scant. But we do know that tragedy struck his family repeatedly.

Before he opened his beer garden, John's older sister, Katherina, and three of her children died in one year, Spraggins says. In 1893, John's mother and sister died within eleven days of each other. The following year (on March 17), John died at home of cancer. He was forty-six. His wife, Emma, survived him; they had no children.

Three months after John died, his wife sold the beer garden to competitors. The Reisch brothers, who owned a brewery and a beer garden in Springfield, bought Krous Park for $9,000. This probably more than doubled Emma's net worth, according to county records.

Nine months after John died, his wife remarried.

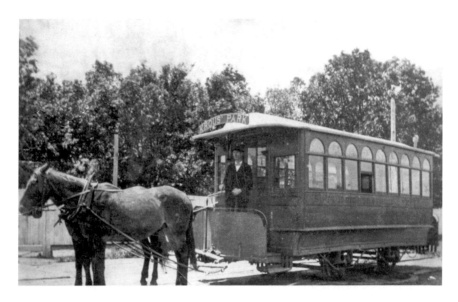

When Krous Park was popular in the late 1800s, many Springfieldians took the trolley to reach it. *Courtesy of the Sangamon Valley Collection, Lincoln Library in Springfield, Illinois.*

One, or both, of the Krouses must have been very proud of Krous Park—so proud that they had a relief of it engraved on their towering monument in Oak Ridge Cemetery, which is located in the cemetery's historic north end. The monument even has a picture of a man, presumably John, on it.

The lot, which John's wife bought shortly before his death (according to cemetery records), is aristocratic. It is marked off by stone and has a private staircase, chiseled with the Krous name.

Then why wasn't John originally buried there?

According to handwritten cemetery records, John was initially buried in an unmarked grave in a separate, humble lot that he and his great-nephew bought when John's sister and mother died. (John's mother has a tombstone there and in his wife's lot.) Seven months after he was buried, John's wife, Emma, had John disinterred and reburied in the plot she bought that features the grand Krous monument.

After Emma and her second husband died, they joined Krous there as well.

SPRINGFIELD BY ANY OTHER NAME

What's in a name?

That was the question on Springfieldians' minds in the summer of 1853. While many people thought the town's name stunk, no one could agree on a new moniker.

Springfield's original proprietors—Thomas Cox, Elijah Iles and Pascal Enos—dubbed the burg "Calhoun" when they platted it thirty years earlier. They named it after John Calhoun, a popular lawmaker from South Carolina, according to *Here I Have Lived: A History of Lincoln's Springfield*, Paul Angle's book about Springfield's history.

Our original settlers weren't crazy about that tag, though. Two years later, Angle added, they had already dropped "Calhoun" and were using the town's original name, "Springfield."

The place was called Springfield before it became a town. "I don't think there is one answer to where the name 'Springfield' came from," says City Historian Curtis Mann. "The area around here had been referred to as Springfield in 1819 and 1820, before the town or Sangamon County were

created, back when we were part of Madison County. Spring Creek is located northwest of us, and there were springs that were flowing in the area, so perhaps the name came from the area's springs."

Simeon Francis, editor of the first local paper, which was originally called the *Sangamo Journal*, didn't care where the original name came from; he simply didn't like it. Francis sparked a spirited debate on August 24, 1853, when he wrote, "The old name—'Calhoun,'—was much better. There are in the United States fifty towns of the name of 'Springfield,' and in any other state than our own, the name…seems to indicate a place of little importance,—besides it is often the cause of confusion in sending mail matter." He opted for "Sangamo" and not "Sangamon." The latter, Francis wrote, was a "corruption" of the Indians' true name and "in bad taste."

One reader, who called himself "Thrifton," lobbied for the name "Illini." (In those days, people who wrote letters to the paper rarely, if ever, used their real names.)

Thrifton argued that "Illini" would be a fitting tribute to a tribe of Algonquian Indians who once lived in this area. Town's names, he wrote, should have historic significance and be interesting. "The endless repetition of old and unhistorical names of towns and cities, betrays a barrenness of invention and a destitution of taste altogether incompatible with the reputed versatility and force of the American genius; and this is especially true in regard to the name Springfield."

Like Simeon Francis, Thrifton argued that Springfield deserved a grander name: "There are so many little out-of-the-way places under the name of Springfield, that people, residing any where but in Illinois, are slow to conceive that a town of this name is worthy to be the CAPITAL of a great State."

Another letter writer, calling himself "Sangamo," wrote that "Sangamo, Illinois" sounded dignified, while "Illini, Illinois" would make people break out in "convulsive merriment."

The *Journal* even printed other papers' thoughts on what Springfield should do. Alton and St. Louis both agreed that we should change our name but disagreed on what it should become. St. Louis' own papers couldn't agree. The *St. Louis Republican* liked "Illini" and wrote that it was "sweet-sounding," while the *St. Louis News* believed that it sounded "light and finicky."

In one of his last letters in the *Journal*, Thrifton argued that a town's name should have a logical connection to the area. "Springfield indicates

the existence of a cherished and valuable spring in the vicinity of this city of field prairie. [It] would be far more [fitting] if our town were called Prairiefield, Prairieton, or Prairion," he wrote. As unfit as the town's current name was, Thrifton said, our burg "might as well be named Beelzebub or Tom Thumb [the star attraction of P.T. Barnum's circus, which had visited town recently]."

A writer who called himself "An Old Pioneer" opposed Thrifton's choice of "Illini," saying that it wasn't an Indian word. (According to several current historians and linguists, Old Pioneer was right about that.) He wrote that French explorers traveling with Joliet and Marquette in 1673 bastardized the name of an Indian tribe they met in this area and developed the word "Illini" themselves. He said the name the Indians gave Marquette—either "Lenna" or "Lenni"—meant, literally, "real men." So, in keeping with the history of our town, he felt its new name should be "City of Men."

After all of the blustery debate, nothing changed. "Springfield" stuck—again.

MORALITY TRUMPS CHOLERA

While cholera raged in central Illinois in the mid-1800s, leaving many dead, it tread lightly on Springfield. Theories about the reasons differed.

The city's great physicians and proactive health supervisors were to thank, wrote local historian Helen Van Cleave Blankmeyer in the article "Health Measures in Early Springfield: The First Half-Century, 1818–1868."

The dreaded disease was caused by bacteria that often thrived in contaminated waters. The stricken could go from healthy to dead within hours; their symptoms included violent diarrhea, vomiting, dehydration and, finally, collapse.

Cholera came to the Prairie State in the early 1830s when Illinois soldiers contracted it in the Black Hawk War, according to Greg Olson's article "Plague on the Prairie." Jacksonville and Bloomington were hit particularly hard.

Olson told the story of Reverend John Ellis, a Jacksonville minister who helped found Illinois College and who lost his whole family to the plague. During the summer of 1833, he left for a short trip. When Ellis returned, his wife and two young daughters were dead.

Although official death records weren't kept then, Olson said about fifty others in Jacksonville died from cholera that summer. Allegedly, hundreds fled the city to escape it.

The Bloomington area had at least seven outbreaks of cholera throughout the mid-1800s, according to Milo Custer's article "Asiatic Cholera in Central Illinois." At its height there in 1855, cholera killed seventeen in one week. Few survived after catching it.

Springfield's health officials were determined to beat it, according to Blankmeyer, even though there were no effective medicines to do so.

In 1832, the city's brand-new board of health initiated an ongoing media campaign to alert Springfieldians to cholera's danger and possible prevention methods. Its July 19, 1832 *Sangamo Journal* ad noted that "Asiatic cholera is now prevailing in Chicago" and told citizens to get rid of possible causes of cholera by removing "all nuisances on their premises." They should "purify by a free use of lime" all privies, sewers and cellars and "remove all vegetable substances in a putrifying [*sic*] condition."

In her book, Blankmeyer wrote, "The Board of Health, every man of them, having insisted upon rented isolation quarters and themselves trained volunteer nurses, gave their services free to the hospital patients and took little time from their ministrations to sleep or eat."

Springfield officials and physicians advised citizens to stay home and stock helpful medicines, including "powders or pills containing 20 grams calomel and 1 grain opium,—a bottle of castor oil, a quantity of powdered mustard, a phial of spirits of camphor, a bottle of brandy, and a quantity of balm, sage, or snake-root," Blankmeyer added.

While all Springfield physicians worked valiantly to spare the town from plague, Blankmeyer credited Dr. Anson G. Henry with helping the most. (He was Abraham and Mary Lincoln's friend and physician.) Henry traveled to Jacksonville to assist its leagues of cholera patients and the physicians treating them, using experimental treatments and learning from their success or failure.

"In Springfield we reaped the benefit of his intensive study, for while neighboring Illinois towns buried their hundreds, the Springfield doctors lost only three cases in 1832, seventeen in 1834," Blankmeyer wrote.

Jacksonville saw things differently.

Henry had written to the Springfield paper from Jacksonville in August 1833 regarding his theories about the plague's horrible hold on the town,

according to Olson. The paper printed his letter, which noted that "moral causes [had] more to do in spreading cholera than physical [causes]," implying Jacksonville's citizens were dying because they were immoral.

It was a pretty harsh thing to say to a city that had lost so many, including a seven-year-old boy.

Understandably, Jacksonville citizens were upset. Its paper printed a rebuttal, protesting that both sinners and saints succumbed to this intestinal tornado.

Regardless of the reason, the plague went easy on Springfield. It had only small, occasional outbreaks in 1851 and 1854, with the last occurring in 1856, although surrounding towns fought it until much later.

As for Henry, he must have been a moral man; he didn't contract it.

BEFORE CORN DOGS AND TAFFY

August in central Illinois means two things: sweltering heat and the state fair. (Nature rarely lets us have the latter without the former.)

The fair wasn't always held in Springfield or during the dog days of summer, though, and it didn't always feature corn dogs, taffy and carnival rides. The first fair was held in 1853 as a gathering for farmers and was sponsored by the newly created Illinois State Agricultural Society, which worried that farmers wouldn't attend.

The society gave Springfield the first choice to host the fair, and the fledgling capital city accepted, donating twenty acres of land for the event, according to the Illinois Department of Agriculture's website. New railroads made travel to and from Springfield easier. As a result, groups like the Illinois State Agricultural Society started to hold conventions and gatherings here, according to Angle's *Here I Have Lived*.

The fair was held after harvest, from October 11 through October 14, 1853. Springfield and the State Ag Society had prepared for months. Simeon Francis, editor of Springfield's *Illinois Journal* newspaper, was an avid fair advocate. Beginning that August, his paper practically begged farmers and Springfieldians to support the event.

"Fellow Citizens!," wrote a member of the State Ag Society in the August 26, 1853 *Journal*, "Can you not, for a single week, remit your toils, [and]

meet your comrades at our Metropolis…to aid in this new effort for the development and perfection of the intelligence and resources of our still youthful, but at no distant day, rich and powerful State?"

"A failure would be a State disgrace," noted the September 8, 1853 *Journal*. The editorial asked editors throughout Illinois to promote the fair. "Push it forward with all your power. Make every one of your readers feel its importance…Agriculture is the great spring from which our wealth is to flow."

The State Ag Society feared that Springfield wouldn't be ready if big crowds attended. Through the *Journal*, it pleaded to the city: "I hope you will have certain arrangements immediately made for the accommodation of at least *twenty-five thousand persons*, and provisions made for erecting bunks and sheds for more in case of emergency requiring it. It will not do to be unprepared."

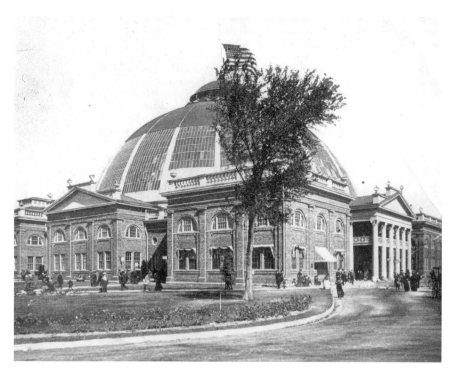

This Dome Building was transported to the state fairgrounds in Springfield from the 1893 World's Fair. It burned down in 1917. *Courtesy of the Sangamon Valley Collection, Lincoln Library in Springfield, Illinois.*

Springfield was unprepared.

Although many locals made accommodations for visitors in their attics or extra rooms, it wasn't enough, according to Angle. "On the night of October 11—opening day—400 were registered at both the American House [a popular Springfield hotel] and the City Hotel, smaller taverns were similarly crowded, and hundreds of men and women who were unable to find accommodations anywhere slept in chairs and on the floors." As fair attendance increased to twenty thousand, visitors had a hard time finding any place to sleep.

Still, "The first fair proved a great popular success," according to *Illinois State Fair: A 150 Year History* by Edward Russo, Melinda Garvert and Curtis Mann. "Altogether there were 765 individual entries with attendance ranging between fifteen and twenty thousand people by the third day, and 'not one inebriated man was seen!'"

The fair focused on family activities and "promoted not only improved methods of agriculture and raising livestock, but also displays of

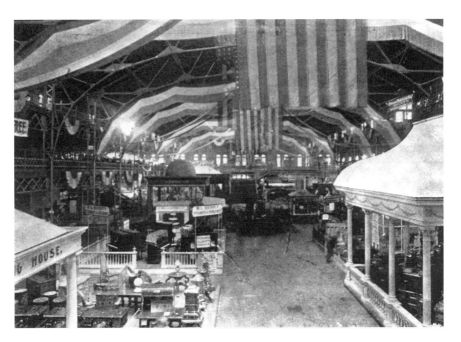

An interior view of the State Fair Exposition Building between 1890 and 1900. *Courtesy of the Sangamon Valley Collection, Lincoln Library in Springfield, Illinois.*

improvement for labor, industry, education, arts, and sciences," notes the Illinois Department of Agriculture's website. Admission was $0.25. At least $944.00 were paid in premiums.

"The fruit department was well supplied, and 'Floral Hall' presented 'a tasteful appearance,'" Angle wrote.

One East Coast journalist wasn't impressed, though. According to the *Illinois State Historical Society Journal*, he wrote, "Swine were more numerous in the streets of the city of Springfield than in the pens of the fairground." (It might not have been an exaggeration—Springfield was known for its porcine problem.)

Despite the pigs, the fair was a success, and the society held another, better-attended one in Springfield the next year. Highlights were speeches by Stephen A. Douglas and Abraham Lincoln.

After 1854, Illinois cities competed to host the state fair, and it was held around the state (with the exception of 1862 and 1893, when there was no fair). In 1894, it returned to Springfield permanently.

THE LAND OF INVENTORS

Central Illinois is not only the "Land of Lincoln," it is the "Land of Inventors," which included Abraham Lincoln. He was the only U.S. president to be granted a patent. Maybe our fertile soil fuels imaginations.

In Lincoln's case, the fuel was his experiences on a flatboat crew. He first arrived in central Illinois on a flatboat in the spring of 1831 and helped sail it to New Orleans. The long, flat-bottomed boats were great for transporting midwestern goods to thriving southern markets, but they often got stuck on sandbars.

Lincoln had a solution: install inflatable bellows beneath the hull that would enable the boat to float over shallow waters. His patent for "Buoying Vessels Over Shoals" was granted on May 22, 1849, but his invention was never manufactured.

The following are some other area inventors.

John E. McWorter: The Helicopter

Many of us have heard about New Philadelphia, the racially integrated town in west central Illinois established by former slave "Free Frank" McWorter in 1836. Free Frank was an enterprising man who bought his own freedom, and that of several family members, and developed this town in which blacks and whites lived in equality.

Few of us have heard of Free Frank's son and grandson, who were inventors. According to the former Illinois State Library Patent and Trademark Depository Library, Free Frank's son, Solomon McWorter, was the first black man in Illinois to receive a patent; he got one in 1867 for an improvement to machines that evaporated sorghum and other syrups.

Solomon's son, John, became an inventor, too, according to John's daughter Helen McWorter Simpson's book *Makers of History*. He read every math and science book he could find and spent hours watching birds fly. His parents made sure that he received a good education at a time when few whites, much less African Americans, got any. That education included a stint at a Springfield high school.

Later, John worked in St. Louis as a mail carrier, but his heart was elsewhere, as evidenced by the trail of experiments he left through his house.

"Wires were stretched everywhere and all kinds of material was on the floor," wrote Simpson. "You walked gingerly…the living room, kitchen and one bedroom were the only places where you were completely safe." Inspiration often struck in the middle of the night, when John could be found at his drawing board, sometimes for hours. His pride and joy was located in the dining room, which had been cleared to make room for a model of his new "flying machine."

In 1911, eight years after Wilbur and Orville Wright made U.S. history by flying their plane, John submitted a patent application for an improved "aeroplane" design. It was granted in 1914, the same year he received another patent for improvements in "flying machines." He got his third in 1922.

His patents were for helicopters, though that name didn't exist at the time. John had designed a "flying machine" that "may ascend vertically from the ground…[and] maintain its lateral and also its longitudinal equilibrium automatically," according to his first patent.

In 1919, John received a letter from the Engineering Division of the War Department's Air Service (the letter is copied in Simpson's book) telling him that a representative was coming to St. Louis on July 31 to review a "trial flight" of his "auto plane" model.

It's not known what, if anything, resulted from that trial. But thanks to Simpson's book, we do know that St. Louis aviator Albert B. Lambert offered John 180 acres of land to test his experimental plane. Today we know those acres as Lambert–St. Louis International Airport.

Presley H. Rucker: The Burglar Alarm

You wouldn't think that the small central Illinois town of Pleasant Plains (just northwest of Springfield) was a hotbed of criminal activity in 1893, but something made resident Presley H. Rucker think he needed a burglar alarm then. So he developed a multifunctional alarm, according to his May 16, 1893 patent. The device was not only "cheap, simple and effective" but could also serve as a doorstop "to prevent the marring of the plaster and wood-work."

Dr. Cyrus G. French: Dental Forceps

Springfield dentist Dr. Cyrus G. French got an extra Christmas present on December 25, 1877. He was awarded a patent for a new kind of dental forceps intended to extract "roots of teeth so frail or wasted, by decay or otherwise, that they cannot be well extracted with ordinary instruments used for that purpose without injury to the gum or alveolar bone." The new design would allow the forceps to "seize a deeper and better hold upon the tooth…instead (as is the case with common forceps) of slipping from off the tooth," according to his patent. Either way, it sounds painful.

William J. Springer: Legislative Voting Machine

At a time when spittoons and gas lamps dotted many state capitols, Springfield attorney and future Illinois state representative and congressman William M. Springer invented a machine that could count lawmakers' votes "in less than a minute," according to his July 20, 1869 patent.

The apparatus would work somewhat like a huge typewriter. Instead of hitting alphabetical keys to make marks, legislators would pull either a "yes" or "no" wire at their desk. The wire, which ran under the floor into a box at the clerk's desk, would move a lever to mark a piece of paper. That paper listed all lawmakers' names. When pulled, the wire would mark a lawmaker's yea or nay vote next to his name on the list.

This enabled the clerk to make "one or ten copies" of legislators' votes immediately and "supply copies to the official reporters and to correspondents of the newspaper-press." Springer thought his invention was virtually foolproof. "It is hardly possible that mistakes should occur," he wrote confidently in his patent.

Illinois must not have agreed. There is no proof that Illinois constructed his voting apparatus. According to Scott Kaiser, assistant secretary of the Illinois Senate, and a January 8, 1951 *Chicago Tribune* article, the Illinois House of Representatives took oral roll call votes until it installed an electronic voting system in 1951. The Illinois Senate took oral roll call votes until the late 1960s or early 1970s, when it had a voting system installed.

A POET'S MYSTERIOUS DEATH

"Famous Poet Succumbs to Heart Attack, Brought City International Recognition" read the headline in the December 5, 1931 Springfield paper, the *Illinois State Register*. It reported that the city's homegrown poet, Vachel Lindsay, had "died suddenly" from "clogging of the coronary artery."

It was a lie, though, and that lie was well concealed for four years. Even today, new evidence is coming to light about Lindsay's death.

Although Lindsay and his talent weren't always accepted or appreciated in his hometown, he achieved acclaim in Europe and throughout America, where he took multistate walking trips or "tramps," trading room and board for his poetry. He believed poems should be performed. His best known are "The Congo" and "General William Booth Enters Into Heaven," which he performed exuberantly, helping create a genre known as "jazz poetry."

Springfield was a temperamental muse for Lindsay; he wrote several works inspired by his love/hate relationship with his birthplace and its people, including one about Abraham Lincoln and another about Illinois governor

Before he became a poet, Vachel Lindsay studied medicine to follow in the steps of his father. *Courtesy of the Sangamon Valley Collection, Lincoln Library in Springfield, Illinois.*

John Altgeld. (Lindsay's home, which is open to the public, is just south of the Governor's Mansion at 603 South Fifth Street.)

Gaining Springfield's approval was important to Lindsay, and he felt that he finally achieved that just one week before his death, when he gave a well-received lecture at the First Christian Church. After the "enthusiastic applause," Lindsay said to a friend, "I feel that at last I have won Springfield," wrote Edgar Lee Masters in *Vachel Lindsay: A Biography*.

Lindsay's career peaked earlier, in 1920, according to Lindsay author and historian Dennis Camp of Springfield. That year "you would have had a hard time finding anybody in this country who was better known as a poet than Vachel…but just nine years later, he was slipping badly." After his marriage in 1925, the quality of Lindsay's poetry worsened, Camp says, and his declining career took a toll on Lindsay emotionally, physically and financially.

"The only thing he could do to support his family was go back on the road performing stale things that he absolutely detested," Camp says. "In

Asheville, North Carolina, he got into a shouting match with his audience and stormed off the stage." According to Masters's book, an audience in Washington walked out on Lindsay a few months before he died.

Although the Springfield newspapers, and Lindsay's physician, claimed that he died from a heart attack, Lindsay actually committed suicide. That fact wasn't made public until four years later via Masters's book.

Masters described Lindsay's last hours as full of "frightful frenzy" that culminated with Lindsay drinking Lysol. "His last words were, 'They tried to get me; I got them first,'" Masters wrote.

According to the Lindsay biography *The West-Going Heart* by Eleanor Ruggles, Lindsay's physician made the decision to lie about the cause of death. Another biography (*Vachel Lindsay: Poet in Exile* by Mildred Weston) states that Lindsay's family "withheld" the cause of death "not so much to conceal it, as to let the original report stand" and that Lindsay's doctor lied because he was "uncertain" whether the family wanted the truth known. Camp says the family and physician lied to ensure payment of a small insurance policy Lindsay had. (The family had little money at the time.)

Several accounts of Lindsay's last years depict him as an emotionally impaired man, given to occasional delusions and rants. Many biographers and historians attribute his depression and suicide to delicate health, failing career and debts.

There was another reason, according to Camp. He began researching Lindsay in 1972, has interviewed Lindsay contemporaries and family, and found unpublished papers from Lindsay and his wife. Camp says that the real reason for the suicide was their failing marriage.

"Vachel sensed, for good reason, that his wife [Elizabeth] was happier when he was away. And his wife expressed the same thing in papers that haven't been published yet. Vachel and she were very, very different," he says. Elizabeth was half his age and a modern woman, while Vachel was more of an old-fashioned, Victorian man.

Lindsay suspected that Elizabeth was unfaithful. "She was clearly very unhappy with him," Camp says. Given the circumstances, Camp calls Lindsay's suicide "an act of courage" meant to help his wife. He says he plans to research the issue further and write about his findings.

Lindsay is buried at Springfield's Oak Ridge Cemetery. His tombstone lists only his name, birth and death dates and the word "Poet."

CLEOPATRA'S SPRINGFIELD ROOTS

While Springfield is primarily known as the hometown of Abraham Lincoln, we have other, less direct claims to fame as well. Oscar-winning actress Elizabeth Taylor, perhaps best known for her 1963 film portrayal of the Egyptian queen Cleopatra and her performance in the movie *Who's Afraid of Virginia Woolf?* has ties to our city, too.

Although the actress was born in London, part of her family roots run deep here. Her father, Francis Lenn Taylor, was born in Springfield on December 28, 1897. (His birth certificate is part of the 1897 Sangamon County Courthouse birth records.)

His parents (Elizabeth's grandparents) were married here as well. According to their February 27, 1890 Sangamon County marriage certificate, her grandfather, Frank M. Taylor, was an "express messenger" when he married her grandmother, Elizabeth M. Rosemond. (Elizabeth Taylor's middle name is Rosemond.)

Her grandmother Rosemond lived at 202 West Monroe here with her father in 1889, according to the 1889–90 Springfield City Directory. Prior to that, Elizabeth's grandmother lived with her family in Taylorville, according to the 1880 Christian County census.

Elizabeth's father didn't stay in Springfield. He and his parents moved to Kansas. Later, he became an art dealer in New York and met and married Elizabeth's mother, Sara, there. The couple moved to London where, in 1932, Taylor was born.

In 1999, she was given the British title of dame commander of the Order of the British Empire, an honor given to accomplished artists with ties to the United Kingdom. So Springfield now has an indirect tie to cinematic and British royalty.

SPRINGFIELD PUT THE ARSON IN ARSENAL

Talk about a checkered past. The State Arsenal—the predecessor of the State Armory, located at the corner of Second and Monroe Streets—took part in some of Springfield's best and worst events. It was a mirror of our city.

Uniquely Springfield

Few Springfieldians remain who remember this jewel, which was a source of pride in its day. Its history dates back to the mid-1800s when its predecessor, the first State Arsenal, was built. That small building was constructed in 1855 at 430 North Fifth Street. It held munitions and equipment for the state's Civil War troops. Supposedly, it was also the site of Ulysses S. Grant's first Civil War job, as a temporary desk clerk for three dollars a day.

In 1901, Illinois' governor, secretary of state and auditor of public accounts were put in charge of building a better arsenal and selling the original. They were allocated $150,000 for the job, according to the Illinois State Archives.

Two years later, the city had a bigger arsenal with a better location—across from the statehouse, at the Second and Monroe corner. Like a symbol of Illinois' might, the castle-like arsenal was considered "one of the most imposing structures in the state," according to the June 4, 1903 *Illinois State Journal*.

The city threw a big bash for its dedication; even the president came.

On June 5, 1903, "All the public buildings, nearly all of the business buildings and many of the residences were gaily decorated in honor of the chief executive's presence," noted the *Journal*.

Eight thousand people waited in the arsenal's great hall for Teddy Roosevelt; not a seat was empty. Large American flags hung from the ceiling.

In his speech, Roosevelt made references to Lincoln and outlined his views of good government. "The safety of the republic is to be found in an honorable administration of the laws of the land…This is not and never shall be a government of a mob," he said. Those words were eerily prescient given what happened at the arsenal five years later.

After Roosevelt spoke, Springfield threw a huge ball. "Five hundred incandescent and forty arc lights" illuminated the room, and two bands, one on each end of the arsenal, entertained, according to the May 20, 1903 *Springfield News*.

"The ball is for all," proclaimed the paper. "It is an occasion when every lover and worker for the city, no matter whether a merchant or clerk, may enter on the same plane and do his part to make the celebration a success." According to the next day's *Journal*, thousands attended.

While the arsenal was used for public events, it was mainly a headquarters and storage facility for the military, which had numerous quarters there. Troops practiced marching in the great hall, ate in the commissary and got treated in the medical facility.

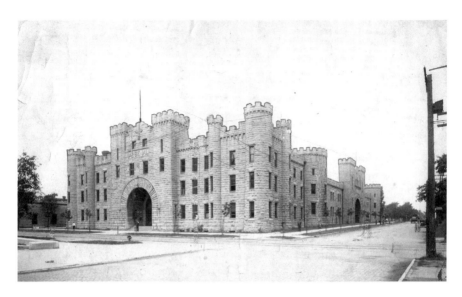

The State Arsenal as it looked in 1903. *Courtesy of the Sangamon Valley Collection, Lincoln Library in Springfield, Illinois.*

The military made room for science, too. The Illinois State Museum moved its collections from the state capitol to the arsenal so they would be "more accessible to the public," according to the Illinois State Museum website.

"In [the arsenal] Springfield welcomed thousands from all parts of the world," said an unidentified newspaper article from Lincoln Library's Sangamon Valley Collection. Numerous events were held here, including concerts, car shows, religious services, circuses and political rallies. (The last two were separate events.)

The list of luminaries who were there is long: Charles Lindbergh, Will Rogers, King Albert of the Belgians, John Philip Sousa and his band, and dancer Ruth St. Dennis, among others. Presidents Calvin Coolidge, William Howard Taft, Herbert Hoover and Franklin D. Roosevelt attended functions there as well, according to the same article.

Five years after President Roosevelt touted the importance of obeying the law at the building's dedication, the arsenal held an impromptu event of a very different kind.

On August 14, 1908, a Springfield mob rampaged downtown, looting, burning black homes and businesses and lynching black barber Scott Burton, who was defending his property. The mob was angry about crimes allegedly

committed by two black men. The men had been arrested and were whisked out of town when the mob threatened to attack them in the jail.

Many blacks, no one knows exactly how many, fled Springfield any way they could. Others found protection at the arsenal. Governor Charles Deneen designated the state arsenal as a temporary refuge "for those blacks who could not or would not leave Springfield, and for those who insisted on returning," wrote historian Roberta Senechal in *The Sociogenesis of a Race Riot*.

The next day, the mob swarmed to the arsenal to attack the blacks inside, but the Illinois National Guard blocked them. Instead, the rioters hurried south a few blocks to the nearby house of William Donnegan, an eighty-four-year-old black man who was married to a white woman. They lynched him in the schoolyard across from his home. No one was ever found guilty of the riot lynchings.

Six months after serving as a fortress for blacks, the arsenal served as a private dinner club for Springfield's white elite. Nearly 760 tuxedo-clad males (along with 1,200 spectators) gathered there on February 12, 1909, for a banquet to celebrate the centennial of Lincoln's birth. The Lincoln Centennial Association, which became the Abraham Lincoln Association, organized the event, according to its website. Lincoln's only surviving son, Robert, attended, as did William Jennings Bryan and the French and British ambassadors.

Blacks, who were unwelcome at the banquet, held their own centennial celebration at Springfield's AME Church across town.

Two years later, the association's annual Lincoln banquet was even bigger, so much so that it warranted coverage in the June 1912 issue of a publication named the *Hotel Monthly*.

Calling it "one of the greatest catering feats attempted in Illinois," the article detailed how the arsenal was transformed into an "Italian garden" to serve 856 guests. President William Howard Taft was a guest speaker. The elaborate menu, which included "green sea turtle" and "roast California squab," was a success, as was "the excellence of the service by Negro waiters."

Six days later, the arsenal caught fire.

"Flames discovered at 12:19…[on February 18, 1934] spread with such whirlwind rapidity that within five minutes the interior of the structure, which covered an area of half a block, was a roaring furnace," reported the next day's *Journal*.

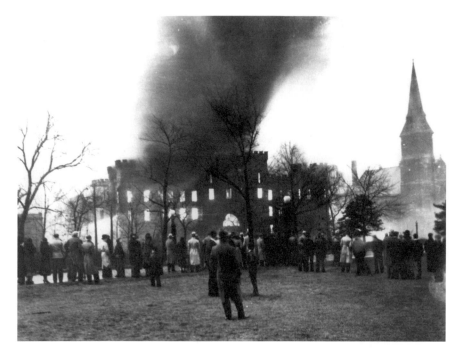

The State Arsenal and its contents were a total loss. *Courtesy of the Sangamon Valley Collection, Lincoln Library in Springfield, Illinois.*

Firemen from the station across the street battled the fire and helped rescue five people trapped on the third floor. Three firefighters "narrowly escaped death" when the roof collapsed and a wall caved in, according to the article.

Even though intermittent rain and snow fell in Springfield that day, the fire was unstoppable—and noisy. "Thousands of rounds of ammunition stored in the arsenal continued to explode with a sound like machine gunning as the conflagration grew," noted the paper.

The explosions led one spectator to hide behind an elm. "What are you doing behind that tree?" another man asked, according to the article.

"Indians," said the careful spectator, who held his position.

All of the city's eighty-eight firefighters battled the blaze, according to the next day's *Register*. "Flames shot from gaping windows throughout the afternoon and well into the evening. Smoke roiled over the statehouse and for blocks away. It filled tunnels connecting the arsenal, power plant, Centennial building, and Statehouse."

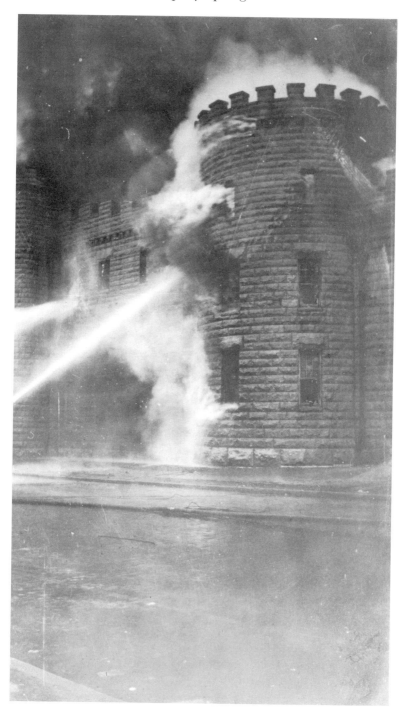

Ammunition at the State Arsenal exploded as it burned. *Courtesy of the Sangamon Valley Collection, Lincoln Library in Springfield, Illinois.*

The arsenal and its contents were a total loss. The state had no insurance on the building. The next day, staff tried to retrieve whatever they could. Some World War I records were permanently destroyed.

Several theories abounded, but no one knew how the fire started. It took the fire marshal and his assistants a week and half of crack detection work to get their man…er, boy.

The arsonist was local ten-year-old Cecil Kiper, pictured in the February 28, 1934 *Journal* with short hair, a bow tie, big ears and a bigger grin.

"Cecil said he walked into the [arsenal] auditorium, found a paper bag on the floor, stuffed into it a solder weight, 'which he always carried with him,' to give the bag weight…ignited it with a match and hurled it toward the curtain," said the February 28 *Journal*.

"He stated that he hardly believed he could throw the bag as far as the arsenal stage, but turned heel and fled…He proceeded home and perused a school textbook entitled 'Good Citizenship,' returning later to watch the arsenal blaze."

The newspapers described Kiper as a budding pyromaniac who started small fires at local hangouts. Authorities took him to the governor's office for questioning. Two hours later, Kiper confessed and was taken to the Sangamon County detention center. His mother protested, but his confession stood.

Kiper's caper made the March 12, 1934 issue of *Time*. The article quotes Cecil's response to Governor Henry Horner's question about why he started the fire: "I like to see burning buildings."

The state's criminologist found Kiper "mentally sick" and recommended that he be placed in a foster home. Instead, Kiper's father took him to New Mexico.

Meanwhile, Governor Horner worked to get the arsenal rebuilt as soon as possible.

Although the Illinois Senate urged the state to build a Lincoln memorial on the site and construct the new armory east of the statehouse (where the current State Library stands), that idea was ditched.

The arsenal's replacement, commonly called "the Armory," was built in the same place as its predecessor. State government began moving into the new building in September 1937.

PART II

BEHAVING BADLY

SPRINGFIELD'S FIRST CON

Maybe Robert Pulliam's rebelliousness stemmed from being born in 1776, a time when revolution was spreading through the land. Then again, maybe he was just a jerk.

Pulliam is considered the first white settler in Sangamon County. He built a log cabin by Sugar Creek in 1817 in what is now Ball Township, south of Springfield and northeast of Glenarm. A marker at the cabin site commemorates him. In 1859, the local Old Settlers Society held its first meeting there and praised the man. But why?

"Pulliam was in court more than ninety times during his life," says David Brady, a Springfield historian and author who has researched Pulliam's court cases (in several counties), probate papers and related documents. "I have about two feet of court records." (His research resulted in the booklet *Hero or Hellion? The Life and Times of Robert Pulliam, Patriarch of Sangamon County*, available from the Sangamon County Historical Society.)

Our famous first settler had an infamous record of charges: attempted rape, attempted murder, battery and assault (against several men and women), perjury, theft and debt.

"Before Pulliam came to Sangamon County, he'd been to court fifty-plus times," Brady says. "The charges varied from harboring slaves to stealing hogs—about everything under the sun." Pulliam, who moved

frequently, had a lot of debt cases. "I believe he was running from the law," adds Brady.

Did our first settlers know any of this when county commissioners named him to the position of county security in 1821? Perhaps they did—it is Illinois after all.

Chronic gambling was part of his problem. Pulliam loved the ponies but didn't have money for his habit. "He would bet other people's property," Brady explains. He bet another man's horse and promised to reimburse the owner if he lost. Pulliam lost, didn't pay for the horse and ended up in court. "This happened several times," Brady says.

Once, in a stand-up moment, Pulliam bet his own horse. He lost. Within one week, he stole it from the winner and went back to court for horse theft.

Ironically, this chronic debtor loaned money one time and learned what he'd put others through. When the borrower failed to repay him, Pulliam was brutal. He broke into the man's house and attacked his wife. "The only thing that saved her was she picked up a wagon hammer and beat him off," Brady says. Pulliam was charged with attempted rape.

When Pulliam first came to Sangamon County in 1817, he only stayed for the winter, but it was long enough to get sued. Pulliam came up from the Kaskaskia River to winter his cows here. A man paid Pulliam twenty-five dollars to fatten his cows over the winter, too. "Upon Pulliam's return, the man discovered his cows weren't fattened and looked pretty worse for the wear," Brady says. So the man sued him.

Pulliam returned in 1819 and settled here with his family. He was the first person to get a liquor license in Sangamon County, according to *History of Sangamon County, Illinois*. He opened a tavern in his cabin and possibly offered more than liquor.

Earlier in Madison County, Pulliam had been jailed for selling liquor without a license. He was charged there in 1812 with operating a "tippling house." The term often meant the tavern was also a brothel.

Brady thinks that Pulliam's tavern here might have been a tippling house, too. His suspicion stems from Pulliam's data in the 1820 census. "Pulliam had like thirteen people living in his one-room log cabin," Brady says.

In terms of offenses, Pulliam hit the big time here, and the case had an ironic outcome.

"Apparently, a man's cattle crossed Pulliam's property," Brady explains. "Pulliam got his gun and threatened to kill the man." Pulliam was found guilty of attempted murder, but Governor Ninian Edwards pardoned him.

Why would a governor pardon the poster boy of repeat offenders? It's hard to say, but apparently they knew each other. "When Ninian Edwards was Illinois' territorial governor, he negotiated a treaty with remaining American Indian tribes…and Pulliam was a witness to the treaty's signing," Brady says. Pulliam was also a stockholder in Edwards's bank, too. Strange bedfellows, indeed.

Pulliam died in 1838, $5,000 in debt, the approximate equivalent of $119,000 today.

THE POLE WARS

In modern elections, political parties show their loyalty with lawn signs. In the 1800s, they used tree poles.

They were erected on main streets and lawns around the country during rambunctious "pole raisings," which attracted large numbers of party faithful and faithful partiers.

In the 1844 presidential election, which pitted Democrat James Polk against Whig candidate Henry Clay, the Democrats erected hickory poles (to honor Democrat Andrew Jackson, "Old Hickory"), while the Whigs chose poles from ash trees, honoring Clay's estate, Ashland.

When it came to poles, there were two rules: the bigger the better, and don't mess with the other guy's pole.

Frequently, however, local rascals would cut down opponents' poles, according to Angle's *Here I Have Lived.* "Then it would be reported that 'some miserable, infamous, low-flung, narrow-minded, ungodly, dirt-eating, cut-throat, hemp-deserving, deeply-dyed, double-distilled, concentrated miscreant of miscreants'" had "sinned against all honor and decency," Angle wrote. Later, when the victims tore down the pole-toppler's pole, the latter would hurl worse words at them.

In 1844, the pole wars turned fatal.

At a sunrise pole raising, to which "sweethearts, wives, and daughters were invited," Democrats erected a 150-foot-tall pole near the sympathetic

Illinois State Register's office (on Adams Street, near Fifth Street), according to Abraham Lincoln Presidential Library and Museum (ALPLM) research historian Bryon Andreasen. Not to be outdone, Springfield Whigs planned to raise the biggest pole in the nation near the office of the Whig newspaper, the *Sangamo Journal* (which was located on Sixth Street between Jefferson and Washington Streets, where the Abraham Lincoln Presidential Library is today). It was 214 and a half feet tall and weighed twenty-two thousand pounds.

On the Whigs' pole-raising day (August 3, 1844), "The city was crowded with delegates from all parts of the State, expecting a grand occasion for congratulation," according to *History of Sangamon County, Illinois*. The crowd gathered at the corner of Sixth and Washington Streets, where an enormous foundation "of timbers and stone sunk 12 feet underground" had been prepared.

A derrick, with an eighty-foot mast, had been constructed to raise the pole. As the raising began, there was a problem, and fifty-year-old mason John Brodie climbed up to fix it. Eighteen-year-old William Conant followed to help.

The derrick fell.

Brodie hung on, while Conant jumped from sixty feet high. Brodie was crushed, and Conant fell "with a sickening thud," the book noted. He fractured several ribs and suffered a compound fracture in his right ankle. He was on crutches for two years and narrowly escaped the amputation of his ankle, which was permanently injured.

Almost immediately, accusations arose that Democrats had booby-trapped the derrick, but a closer look revealed that the real culprit was structural problems, not malice.

The local Whig Club met four days after the accident, and member Abraham Lincoln introduced a resolution related to the mishap, which the club approved. (The full resolution is in the first volume of the *Collected Works of Abraham Lincoln*.)

It noted that out of "a profound respect" for John Brodie "and the peculiarly afflictive manner of his death," the club would appoint a committee to see if Brodie's family would let it erect a tombstone on Brodie's grave. In addition, the committee would keep in touch with Brodie's widow to determine how the club could assist her and her family on an ongoing basis.

Lincoln, other Whigs and even local Democrats tried to help the young, injured William Conant. "Mr. Lincoln was almost constantly by [his] sick bed," according to *History of Sangamon County, Illinois*. "As soon as he was able to leave the house, Mr. Lincoln took young Conant to a Whig demonstration in Jacksonville, making the journey by easy stages in a carriage."

Undeterred, the Whigs tried again to raise their mega "Liberty pole." According to the *Sangamo Journal*, they succeeded after two hours—twenty days after their original, disastrous first attempt. This time, there were no injuries or deaths.

It didn't help. The Whigs lost.

BLOW-BY-BLOW JOURNALISM

Today most newspapers claim to be politically neutral, but that wasn't the case in Springfield in the 1800s, and the result was sometimes violent.

"Newspapers were expressly partisan," says Bryon Andreasen, research historian with the Abraham Lincoln Presidential Library and Museum. "So [back then] you read the *Sangamo Journal* if you were a Whig, and you read the *Illinois State Register* if you were a Democrat."

In its formative decades of the 1820s and 1830s, Springfield was a southern-sympathizing town due to the many settlers who'd come from that area, according to *History of Sangamon County, Illinois*. When Simeon Francis and his brother moved here from Connecticut and started their paper, the *Sangamo Journal*, in 1831, the town wasn't too happy. "Even in those days a Yankee was distasteful to people from South of the Ohio. Certain persons at once raised a cry against the paper, and went so far as to say there [were] some people in the county who would not give the Francis brothers a place to be buried in, if it was known where they came from."

In 1839, the Democratic paper, the *Illinois State Register*, moved to town, and things got really interesting. Each paper proudly proclaimed its partisanship, unflinchingly bashing political opponents and their causes while applauding political peers. The *Register* backed local Democrat Stephen Douglas (who later became a U.S. representative and then U.S. senator), and the *Journal* backed local Whig Abraham Lincoln.

The *Journal* so "vehemently supported" Lincoln and the Whigs that in 1840 Stephen Douglas tried to hit Francis (the *Journal* editor) with a cane in public, according to Mark Neely's *The Abraham Lincoln Encyclopedia*. Andreasen elaborates: "Douglas went up and tried to cane Simeon Francis and Francis grabbed him by the back of the hair and threw him against a cart."

That was nothing compared to the blowout that happened in 1849—between editors, no less. It all started when the *Register* took the *Journal* to task for something it printed three years earlier disparaging the Mexican War. It believed the offending paragraph was unpatriotic and unsupportive of local troops leaving for the war.

The *Journal* said the paragraph was reprinted from another paper by mistake and didn't represent its feelings about the war, but the *Register* editor refused to drop the issue. "He can have no apology for doing this, but that of his excessive drinking and sottish life," the *Journal* editor wrote.

Ho boy.

The next day, the *Register* editor said the *Journal*'s story was a lie and the *Journal* editor was an "imbecile apology for a man." That afternoon, June 15, 1849, the fight leapt from the pages to the streets. That much the papers agreed on.

On June 16, in an article titled "Four Battles in One Day! Battle of the Eggs—Street Fighting—Club Fighting—The Battle of the Pitch-Fork," the *Journal* recounted its version of events. "While we were innocently amusing ourself cracking nuts, in the store of our neighbor," one of the *Register* editors came inside the store and "commenced an attack upon us with a cudgle," it wrote. So the *Journal* editor threw him into some eggs.

"Snake like [the *Register* editor] managed to get hold of our little finger, and raised the skin slightly—the wound in itself is trifling; but we apprehend serious consequences from the poison," it continued.

The city marshal ordered them to the office of the mayor, who the *Journal* believed was in on the attack. On the way there, the group ran into the other *Register* editor, Charles Lanphier, who attacked the *Journal* editors with "a bludgeon and a two pound weight."

Then, according to the *Journal*, the *Register* editor who started the whole brouhaha came up from behind and "dealt us blows," forcing the *Journal* men to defend themselves with a pitchfork, thus ending the "four fights in one day" against the *Register*'s "cowardly pack of hounds."

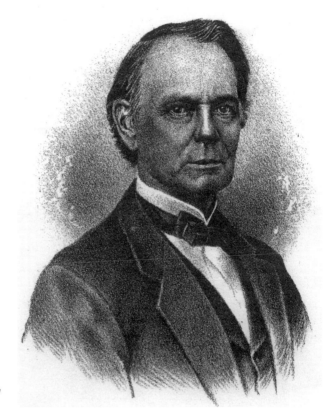

Charles H. Lanphier, *Illinois State Register* editor, was an avid Democrat who held leadership positions in Springfield and unsuccessfully campaigned for state treasurer. *Courtesy of the Sangamon Valley Collection, Lincoln Library in Springfield, Illinois.*

The next day, it was back to business as usual. The *Register* called the *Journal*'s story a lie from beginning to end, and a day later the *Journal* said the same thing about the *Register*'s story.

A Capitol Affair

The architect of Illinois' first statehouse in Springfield had a lot of things on his mind. Sure, John F. Rague thought about creating a worthwhile capitol for Illinois. But he also thought about women, especially women other than his wife.

You see, Rague was a rogue.

"In spite of his many talents, John F. Rague had a serious defect in his personality," wrote Sunderine Wilson Temple and Wayne C. Temple in

their book *Abraham Lincoln and Illinois' Fifth Capitol.* "He chased women and sometimes caught them."

While living in Springfield, Rague managed to oversee the initial construction of the capitol (now the Old State Capitol in the heart of the city's downtown) and fit in at least one affair.

Rague and his wife, Eliza, moved to Springfield from New York in 1831, according to the Temples' book. Rague quickly put an ad in the Springfield paper promoting his services as a baker and architect. (Their book notes that he also taught Sunday school, performed as a vocalist and musician and became a trustee for Springfield. In addition, he headed a church choir, according to Angle's *Here I Have Lived.*)

When the legislature voted to move the state's capital from Vandalia to Springfield in early 1837, Rague was among the many locals who would benefit. A contest was held to choose blueprints for the state's new capitol,

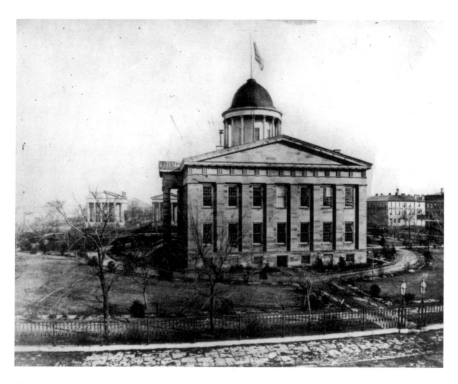

State senators first met in what is now the "Old State Capitol" on November 23, 1840. Because their chamber wasn't finished, state representatives met at a church. *Courtesy of the Sangamon Valley Collection, Lincoln Library in Springfield, Illinois.*

and Rague's Greek Revival–style structure won. He was paid $200 and became the statehouse's architect. That led to another prestigious contract; Iowa asked Rague to build its capitol, too. He "quickly modified" Illinois' statehouse plans and sent them to Iowa, according to the Temples. (Ironically, Iowa later got the plans for our current statehouse, too.)

On July 5, 1837, the day after the cornerstone was laid on the capitol in Springfield, Rague signed a contract vowing to "devote his whole time and attention to the work."

He must have had his fingers crossed when he signed it.

"In Springfield…John committed adultery with one Mary Ann Campbell, a servant girl living [with] their family at that time, this was in or about the years 1841 and 1842," noted the divorce plea that Eliza filed in 1853 in Sangamon County. (The Rague divorce papers are located in the Illinois Regional Archives Database at the University of Illinois–Springfield.)

Perhaps Rague was seeking solace. In 1841, due to financial overruns and construction delays, the legislature replaced him and the statehouse commissioners with state officials.

The next year, the Rague family (they had six children, though only one lived to adulthood) moved to Milwaukee where Rague ran a gym and a commission business and worked as an architect—while engaging in more extracurricular activities.

Rague had an affair with his family's servant girl, Mary Tripp, who lived with them in Milwaukee. According to divorce papers, Rague "hastened" his wife to visit friends in Springfield "in order that she might not be present at the exposure of his criminal intercourse with Mary Tripp." While his wife was gone, Tripp had a baby.

That wasn't the end of his rascally ways. In 1851, he had an affair with Martha Forsyth, a married woman who was boarding in the Rague household while her husband was away.

Rague's wife found notes that Forsyth had written to Rague. Two had been thrown away in his office spittoon (one was ripped into several pieces) and another, intact, was in his vest pocket. (The letters, even the ripped and reconstructed one, are in the Rague divorce file at the University of Illinois—Springfield.)

The faded, torn, 155-year-old love notes hint at an insecure, scheming couple.

"Mrs. D. said I would be in a brothel in less than a year," Forsyth wrote in one. "What do you think of that?"

"If she goes to church you can go in with her and sit a moment, then come out. Please be where you will not see me when I go out. They will think I ran away from you," she said in another.

"There has been a terrible talk [about] you. Do not come to my room. Meet me at church yard at nine," Forsyth wrote in still another.

By this time, Rague was an alcoholic, according to the divorce papers. "For the last 3 years John has become more and more addicted to the use of intoxicating liquors, frequently returning to his home drunk."

In 1853, Eliza Rague left her husband and returned, with their daughter, to Springfield, where she filed for divorce, claiming that her husband's adultery was "publicly notorious" and his "licentiousness" (drunkenness) had become so established that there was "no reasonable hope of his reformation."

She remarried in Springfield five years later. Rague remarried almost immediately to a girl thirty-two years his junior, according to the Temples' book.

He is buried in Dubuque, Iowa, their book notes, "between his two wives."

WAS SPRINGFIELD HELL?

Historians have attributed Springfield's deadly 1908 race riots to many factors. Chief among them was racial strife. But what caused the racial strife? A radical "reformer" of the time said that it was Springfield's vice district.

"The saloon has degraded both black and white citizens and engendered this bitter race hatred," wrote William Lloyd Clark. "Wipe out the saloon and you settle the race question."

Clark was a vociferous anti-saloon, anti-Catholic protester who ran an independent press in Milan, Illinois (near Moline), to spread the word about the evils of bars and Catholicism and everything related to them. On July 1, 1909, he spent "six long weary hours through the 'bad lands'" of Springfield, visiting its denizens to research his book *Hell at Midnight in Springfield: or a Burning History of the Sin and Shame of the Capital City of Illinois*. Clark published the book in 1910 to "dethrone viciousness" and "establish law and order in the Capitol [*sic*] city."

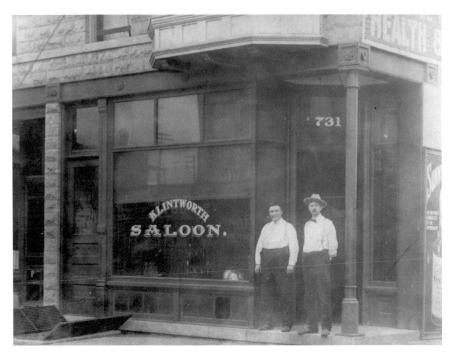

This 1906 photo shows a typical Springfield bar of the time—the Henry Klintworth Saloon on the northwest corner at 731 East Adams Street. *Courtesy of the Sangamon Valley Collection, Lincoln Library in Springfield, Illinois.*

While the book is a long rant against his favorite targets, it has detailed descriptions of a part of Springfield that most locals wanted hidden—a sizable vice district that operated openly downtown. Here's what Clark saw:

> *Northeast from the corner of Sixth and Washington Streets* [just south of where the Abraham Lincoln Presidential Library now sits] *for many blocks* [east]*, the city of Springfield is a mass of dive saloons, pawn shops, questionable hotels, fourth rate lodging houses and assignation resorts, stench restaurants and brothels from the lowest ramshackle hovels to the most richly and elaborately equipped which can be found anywhere in the State…*
>
> *It is true, workingmen are there by the thousands, dissipating away their hard earned wages, while their families suffer in poverty and their children are deprived of an education. But the slum must have its rich devotees who can buy champagne at four dollars a throw and pay fancy prices for fancy women…*

At all hours, from ten o'clock in the evening to four o'clock in the morning, the cabs, carriages and automobiles can be seen stopping in front of Madam Browning's richly and luxuriously furnished place, or the palatial brothel presided over by the old Jezebel known as Helen Paines…

I think it was about 10:30 I saw an auto loaded with fashionably dressed men and women stop in front of Dave O'Connor's "House of David" on North Sixth Street. They ordered the drinks delivered, and out in the public street laughed and shamelessly quaffed the beverages of Hell…

The saloon dominates this entire district…In nearly every one of these saloons there is a side stairway so arranged that one can pass from the bar room into a hallway and upstairs without passing out upon the street…these places are used for gambling or prostitution, or they are assignation houses.

About ten o'clock the street woman makes her appearance. They are mostly girls who have served an apprenticeship in the house of shame… Many are girls whose beauty has faded until they are no longer desirable for brothel service…

[Starting at the corner of Washington and Sixth Streets and walking east four blocks, past where Horace Mann is today] *one passes twenty-five saloons, most of them so vile and stench that it is utterly impossible to describe them. And this is a main thoroughfare over which hundreds, or possibly thousands of men, women and children pass daily. Negro dive saloons, Bohemian saloons where the English language is never spoken…You enter one of these places and low-browed brutish red eyed animal-men will stare at you. The air is foul and stifling. Faded vulgar pictures look down at you from dirty, dust-covered walls…*

Just off Washington, on North Eighth street…is located an undertaking establishment, and this brings us to the mammoth brick and brown stone front building where Madam Helen Paine conducts the most fashionable and the most extensively equipped brothel in the state capital…

Madam Helen Paine opens the door with a welcome smile and asks you if you desire to see any girl in particular. If not, she calls her bevy, of which she possesses a rare collection; from girls that look to be in their teens up to wise old sirens who know all the ropes that will help a fool to part with his money. You are ushered down a long hallway into a room that is worthy of special notice.

Behaving Badly

Some of you prosperous people of Springfield could put all your fine furniture into this room and still it would hold more. Its floors are of hard wood highly polished and waxed. Around the walls are costly couches and divans. Pictures, questionable too, look down at you from the richly papered walls.

The Madam has ushered you to a seat, it is early and but few girls have company. She touches a button in the wall and instantly her "Birdies" commence to arrive; they come down the stairway, up from the basement, from everywhere. They seat themselves about the room. Some one will start a conversation, usually they want to know if you are a stranger in the city.

You are soon informed that you must choose your company, time is money—and girls come high in this place. If you want to see how beautifully the rooms are furnished upstairs it will cost you five or ten, or if you are not careful it will cost you your entire pocketbook.

Suppose that while you are chatting in this great reception room, the door bell rings and another caller appears, rest assured you will never see him. He will be directed to another room just as large and just as fine in its furnishings, and another bevy of girls ushered in for its entertainment. Men are never allowed to face each other inside this place unless they came to the house together. It is not considered safe, as brother might meet brother, father might meet son; for it is said that not long ago there came near being a tragedy when a young man came face to face with the husband of his own sister in a Springfield brothel.

But why are some of these rooms so large and commodious? Let us drop down there at midnight when the automobiles have been stopping in front and enter and we will see these large rooms turned into dance halls, and we will see young men from the first homes of Springfield folded in the volumptuous [sic] embraces of fallen women.

Clark blamed Springfield's leaders for the open vice. "[It exists] in violation of the ordinances of Springfield and the statutes of Illinois. [It exists] with a full knowledge of the Governor, the Mayor, the Sheriff, the Chief of Police, the Prosecuting Attorney, and the whole miserable mess of time servers who hold their honor below par and sell the manhood of the state and city to the saloon and brothel in exchange for a miserable mess of political pottage."

He said the badlands "were an open school of crime" that fostered Springfield's 1908 race riots. "The city has reaped its reward in a mighty whirlwind of death and blood."

Clark was arrested the year after the book's publication on obscenity charges related to it. A federal court in Peoria found him guilty and fined him $455. In later books, Clark said that the charges were part of a larger attempt to shut down his press. It didn't work. He was printing his newspaper and books years later.

His book didn't shut down Springfield's vice district either. It stayed in business for many years, too.

ALL THE NEWS THAT'S FIT TO PRINT

Reading Springfield's old newspapers gives a fascinating look at past events, changes in social attitudes and mainstream journalism over the years. One difference is that there was no privacy about personal matters, even if they related to physical or mental health.

Nose jobs were front-page news. "Louis Stranger in Home Town; Has a New Nose" was the title of the December 28, 1916 *Springfield News-Record* front-page article. It told about Louis Lebrucher of Beardstown who was "getting reacquainted with all his friends again" after cosmetic surgery. "Louis has a new nose, straight and beautiful like the classic Grecian mould," the article noted. "While Dr. E.E. Hagler was operating on him some time ago, he suggested that he make a new nose reducing the enormous size and taking out the hump. Lebrucher consented and Dr. Hagler laid the bone bare, chiselled off about half of it, and sewed the flesh and skin back into place."

Not only was there no privacy in the old papers, there was no sensitivity either. The *Illinois State Journal* on March 15, 1860, announced that a local man was "Going to the Asylum." It reported, "William B. Turner, a lunatic, started from this city for the State Asylum at Jacksonville yesterday afternoon. He was in the county jail for about two months. It is supposed that his madness is deep-seated."

In the 1800s, the city's two papers, the *Journal* and the *Register*, presented diametrical political viewpoints. The *Journal* was Republican and the *Register*

was Democratic. The two rarely agreed on anything but the day's date, and they didn't hide it in their pointed and sometimes biting editorials. Their rancor peaked on July 15, 1847, when the *Sangamo Journal* responded to a left-handed compliment the *Register* had given it. The *Journal* noted, "The State Register editors, who have been groping their way in darkness hitherto, have made the discovery that the Journal ediot [*sic*] is 'honest.' We are sorry that we cannot at present reciprocate the compliment."

Like today, the old papers reprinted items from other cities' newspapers, which was the only way to get national news. In 1833, the *Sangamo Journal* reprinted such an article, which had to be one of the first personal ads ever written. The December 21 article from the *New York Evening Star* was titled "Wives Wanted," although the man was only looking for one. The *Journal* editor added, "The [New York] editor…assures us that [the article] is genuine." The article noted, "A gentleman of high respectability, moving in the first circle of society, twenty-four years of age, of agreeable person, and who has improved himself by traveling on the continent of Europe, is anxious to take himself a wife. Being a decided original, he has resorted to this method of procuring one."

There was a curious postscript. It was a friend's testimony about the gentleman's worthiness. The friend said that the bachelor was "a disciple of 'Plato,'" so "no woman could fail of being happy with him." (The way to a woman's heart was philosophy?) The friend implored women to consider the gentleman's plea because "he is rapidly sinking into a state of indifference towards [women]."

The friend's final tactic might have been the most effective. He wrote: "[The gentleman] has $30,000 in the U.S. Bank Stock."

The optimist award goes to an article from the November 20, 1916 *Springfield News-Record* about a local hunter. While quail hunting, he shot his dog. Once he was home, he realized that his gun had fallen out of his buggy. However, he got two birds, which the paper obviously viewed as a success. It titled the article "Kills Dog, Loses Gun, Otherwise it was a Swell Hunt."

PART III

THE LINCOLNS

LINCOLN AND THE THESPIANS

Theatre had a shaky start in Springfield. After the town was settled and life's basic needs were mostly met, residents wanted to have fun. But then, as now, one person's amusement was another's sin.

Those with a taste for the limelight created a "Thespian Society" in November 1836, according to Angle's *Here I Have Lived*. Members performed in taverns, the American House hotel (at the southeast corner of Sixth and Adams Streets), the courthouse (at the southeast corner of Sixth and Washington Streets) and "Watson's saloon" on the downtown square, according to June 28 and 30, 1936 articles in the *Illinois State Register* and *Illinois State Journal*, respectively.

The society's first production was such a hit that it gave an encore performance.

Nonetheless, the group had to assuage locals who thought theatre was immoral. The society responded that the town's best and "most respectable" citizens attended its shows, which benefited charity.

A few years later, a professional theatrical company performed here. That was too much for the theatre haters.

Perhaps motivated by recent religious revivals, critics denounced theatre (and novels) as un-Christian, according to Angle. One resident wrote to the Springfield paper, the *Illinois Republican*, that theatre was "a school of vice,

a hot bed of iniquity…[and] the spot where the bonds of virtue are first loosened, and finally dissolved."

Theatre companies countered with a public relations campaign emphasizing their focus on "virtue" and condemnation of "vice." It wasn't enough.

As more professional companies came to town, the "moralists" increased their campaign. They preached against theatre from the pulpits and convinced the city council to charge companies a nightly performance license that was so costly many companies couldn't perform, according to Benjamin McArthur's article "Joseph Jefferson's Lincoln: Vindication of an Autobiographical Legend."

However, one company, the Chicago-based Illinois Theatrical Company—featuring the legendary theatrical family of Joseph Jefferson II—fought the local license requirement. It came here to perform in July 1839 to take advantage of the state capital moving to Springfield from Vandalia that month. The legislature would be in session, and the town would be full of people seeking entertainment, explained Joseph Jefferson III in *The Autobiography of Joseph Jefferson*. (Jefferson III became such a famous actor that some call him the "dean of American theatre." Chicago's Tony-like "Jeff" awards for theatre professionals are named after him.)

According to Jefferson III, Abraham Lincoln offered to help the company fight the licensing fee and approached the city council on its behalf. (Lincoln was a city council member by this time.)

"He handled the subject with tact, skill and humor, tracing the history of the drama from the time when Thespis acted in a cart to the stage to-day [*sic*]. He illustrated his speech with a number of anecdotes, and he kept the council in a roar of laughter; his good-humor prevailed, and the exorbitant tax was taken off," he wrote in his book.

Jefferson wrote down this memory decades later and might not have remembered everything correctly. For instance, he said Lincoln helped the company for free, but a July 7, 1839 document in the Papers of Abraham Lincoln (at the Abraham Lincoln Presidential Library and Museum in Springfield) notes that Lincoln and his law partner received $3.50 and $1.50, respectively, for providing legal services to the company. Jefferson also said that Lincoln got the tax "taken off," but minutes from the July 23, 1839 city council meeting show that the council voted to make the

performance license $3.00 per night, retroactive to about a week after the company began performing.

Lincoln's assistance, whatever it was, may have helped the company, but a glowing review for it in the paper couldn't have hurt. The July 12, 1839 *Sangamo Journal* reported that the company was playing to such large crowds "the audience are compelled to laugh perpendicularly" for lack of space.

THE LINCOLN CONTROVERSY THAT WASN'T

Abraham Lincoln must have been tired.

It was October 1860, one month before his first presidential election. Between that, his busy Springfield law practice and his trio of rascally boys, he probably needed a boost.

Some respected historical sources state that he used cocaine to get it.

Lincoln's alleged cocaine purchase was originally published in the frequently cited book *The Personal Finances of Abraham Lincoln* by Harry E. Pratt. It analyzes Lincoln's finances and lists credit purchases his family made at Springfield's popular downtown drugstore, Corneau & Diller's.

According to the book, on October 12, 1860 the Lincoln family purchased fifty cents' worth of cocaine, among other items.

Today, an allegation like that could destroy you, but cocaine was originally legal and found in common medicines and wines that could be purchased over the counter at your local store.

Drugstores then offered a cornucopia of now illegal or controlled substances. Corneau & Diller's sold other Springfieldians morphine, laudanum, chloroform, quinine, opium pills, mercury and belladonna (from the deadly nightshade plant), according to its ledger. And that was just over three months. Clearly, Civil War–era central Illinoisans were well medicated.

In 2005, author Joshua Wolf Shenk theorized that Lincoln took cocaine for his depression. His book, *Lincoln's Melancholy*, argues that Lincoln's depression gave him the tools to be an effective president during a turbulent time.

Shenk theorizes that Lincoln tried treating his depression with a variety of medicines, including "fifty cents' worth of cocaine" from the "Corneau and Diller drugstore." He repeated that assertion in a September 2005 *Atlantic Monthly* magazine feature about Lincoln's depression.

He isn't the first to publicize Lincoln's self-medicating practices. In 2001, physician Norbert Hirschhorn and professors Robert G. Feldman and Ian A. Greaves described in the summer issue of *Perspective in Biology and Medicine* their theory that Lincoln was poisoned from taking too many "blue mass pills" (which contained the toxin mercury). These were often prescribed for melancholy and other maladies.

Since Lincoln took mercury pills to ease his blues, it's not a far stretch to think that he used cocaine to help, too. After all, Lincoln's depression was quite severe at times, according to several of his friends and colleagues—and even Lincoln himself.

Other respected media cite Lincoln's alleged cocaine purchase, giving it further credence. These include the website of the National Park Service, which oversees the Lincoln Home. All references cite Pratt's *Personal Finances of Abraham Lincoln* as the source.

But Pratt was wrong.

The drugstore's original ledgers, which are brittle old tomes carefully wrapped and kept at the Abraham Lincoln Presidential Library in Springfield, hint at the root of the problem.

In flowery handwriting, the ledger lists several credit purchases for the Lincoln family on October 12, 1860, including "cocoaine." Two other Springfieldians also bought "cocoaine" that year, according to the record. Their entries list "Bot. [abbreviation for "bottle"] Cocoaine."

Of course, some words were spelled differently back then, which has caused problems with historical interpretation. For instance, the ledgers spelled "cigars" as "segars." Pratt's book assumed the ledger's "cocoaine" meant cocaine.

Not likely, says drug historian Dr. David Musto. He has written four books about drug regulation and history, is a Yale Medical School faculty member and has been a White House advisor on drug policy.

"It's virtually impossible that Lincoln purchased cocaine in 1860," he says. "Cocaine wasn't even isolated from coca leaves until 1860 by a scientist named Albert Niemann in Germany."

Given slow transportation, communication and production back then, Dr. Musto doesn't think that companies could have produced commercial quantities of cocaine the same year it was isolated.

Nobody paid much attention to Niemann's cocaine discovery anyhow. "Ten years went by before anyone even bothered to confirm his observation

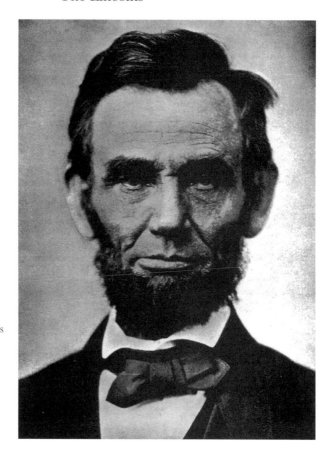

Abraham Lincoln later in life. Many of Lincoln's friends commented on his awkward, gangly appearance and disheveled clothes. *Courtesy of the Sangamon Valley Collection, Lincoln Library in Springfield, Illinois.*

that cocaine crystals made the tongue numb," according to Steven Karch's *A Brief History of Cocaine.*

So if Lincoln didn't buy cocaine, what did he buy? Hair tonic—a boost for his follicles, not his neurons.

Perhaps ol' Abe was more vain than we thought. "Cocoaine" was a remedy for dandruff and baldness in the later 1800s and went by the brand name Burnett's Cocoaine. It was made by Joseph Burnett in Boston from the oil of cocoanuts (an alternative spelling of coconuts), hence its similar name.

Burnett's hair tonic was popular nationwide. "I have used the contents of one bottle, and my bald pate is covered all over with young hair, about three-eighths of an inch long, which appears strong and healthy, and determined to grow" noted a customer testimonial in a November 21, 1863 *Harper's Weekly* ad.

Did Corneau & Diller's sell it at the time of Lincoln's purchase?

The answer is found in a front-page ad in the Springfield paper, the *Illinois State Register*, on the day before Lincoln's purchase—October 11, 1860. It says:

Cocoaine *Burnett's, for the hair*
At *Corneau & Diller*

The hair tonic must have been in demand, because another Springfield store also advertised it.

Lincoln didn't buy cocaine; he bought hair tonic for his unruly mane. Our soon-to-be sixteenth president wasn't looking to feel good; he wanted to look good. Who can blame a presidential candidate for that?

THE PRESIDENT IS SHOT

On April 14, 1865, Abraham and Mary Lincoln were enjoying a well-deserved night out. The South had just surrendered, and the Civil War was over.

The Lincolns decided to see *Our American Cousin* at Ford's Theater in Washington, D.C. We all know what happened next, but there's nothing like hearing it from an eyewitness.

Helen A. Bratt DuBarry was a young military wife living in Washington, D.C. at that time with her husband, Beekman. He was the assistant to the commissary general of subsistence for the war and appeared to move in top circles.

On April 14, Beekman heard that the North's new hero, General Ulysses S. Grant, would accompany the Lincolns to the theatre that night. The DuBarrys wanted to see Grant, the Lincolns and the play, so they went, too. Helen wrote to her mother about it two days later. Her letters are in the Abraham Lincoln Presidential Library and Museum manuscript collection in Springfield.

Although the DuBarrys arrived early to see the country's leaders, the Lincolns were late. (Grant left for home instead of attending the play.) It was the middle of the second scene when the audience applauded their arrival.

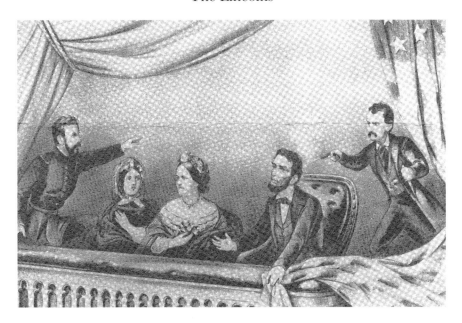

This illustration of John Wilkes Booth shooting Lincoln was a Currier and Ives lithographic print. *Courtesy of the Sangamon Valley Collection, Lincoln Library in Springfield, Illinois.*

Helen wrote that two gentlemen "in citizens dress" accompanied the president as "watchmen" and said that they "have *always* accompanied the President since the war commenced."

"We followed [Lincoln] with our eyes until he entered the [presidential] Box little thinking we were looking for the last time at him."

Mary sat in front of Lincoln, whose back was toward the DuBarrys. She seemed happy and smiled at her husband often, Helen wrote.

It was while every one's attention was fastened upon the stage that a pistol shot was heard causing every one to jump...and look up at the President's Box merely because that was the direction of the sound and supposing it to be part of the performance, we all looked again on the stage, when a man suddenly vaulted over the railing of the box, turned back and then leaped to the stage, striking on his heels and falling backward but recovered himself in an instant and started across the stage to behind the scenes flourishing a knife—the blade of which appeared in the reflection of the bright lights to be half as long as a man's arm, and making use of the expressions you have seen in the Papers. [Other accounts say that John Wilkes Booth

cried "The South shall be free!" and "Sic semper tyrannis!" which is Latin for "Thus always to tyrants!"]

The crowd sprang to its feet, and someone shouted that the president had been shot. The presidential box was silent.

Mistakenly, a man heard that the murderer had been caught and shouted, "Take out the ladies and hang him here on the spot," DuBarry wrote.

Fearing what might happen, her husband rushed Helen out of the theatre, where they waited for news about the president. "A young man came out and said, 'He is dead—no doubt about it!'"

Helen began sobbing. As they lingered in the street, strangers approached them and asked if the rumors about the president were true. She said that the crowd was in shock partly because no one believed that a murderer could get into the president's box. Helen recounted what she heard had happened:

> Booth entered the front door [of the theatre] and asked some one there if General Grant was there that night—then went along to the door of the Box—just where we had seen the President enter—knocked at the door and to the watch who opened it, said he wished to speak to the President, that he had a communication for him showing an official envelope and giving him a card with the name of a Senator written on it. The watch stepped aside and the assassin entered and fired immediately...

Later that night, about two thousand angry rioters thronged toward the city's Old Capitol Prison, which held Confederate prisoners of war, but police stopped them before they could burn it.

Even local Southerners were upset, Helen wrote. They draped their homes in crepe (a mourning custom) and feared that the new president, Andrew Johnson, would be harsher on the South than Lincoln had been.

When Helen wrote to her mother again on April 25, she said she had been physically sick from that night at Ford's Theater. Even so, she was sorry she hadn't viewed Lincoln's body at the White House and felt bad for Mary Lincoln, who was disconsolate.

"Poor Mrs. Lincoln has not left her bed since he died and they had to close the doors a half hour before the appropriated time [of the viewing] as the

steady tramp tramp of the people was making her wild so that she did not recognize her own son."

Lincoln's casket was placed in Springfield's Oak Ridge Cemetery on May 4, 1865.

SPRINGFIELD'S LONG GOODBYE

On the morning of Wednesday, May 3, 1865, thousands gathered along Springfield's railroad tracks and at the Alton and Chicago Railroad depot (the current Amtrak station, between Jefferson and Washington Streets). They were watching for the train that carried the remains of Abraham Lincoln. "Every building and house top in the vicinity was covered with anxious and solemn men, eager to see the funeral train," said the May 4, 1865 *Illinois State Journal*.

Springfield was the final destination of the train's thirteen-day trip from Washington, D.C. About one hundred Springfieldians had traveled to Chicago earlier to accompany the train back home.

A few minutes before 9:00 a.m., the pilot engine arrived; it was draped in dark cloth, which was the Victorian symbol for mourning. The similarly decorated nine-car funeral train followed ten minutes later. "The feelings of the people were intense, but only manifested by the almost breathless silence which pervaded the vast crowd," the *Journal* reported.

"The remains were then transferred from the funeral car to the beautiful hearse tendered by the Mayor of St. Louis to [Springfield] Mayor Dennis… drawn by six superb black horses, draped in mourning and wearing plumes upon their crests. The hearse was also draped, the corners being augmented with black plumes."

A huge escort of military units, state and federal officials, friends and some relatives accompanied the hearse through downtown, ending at the Hall of Representatives in the statehouse (now the Old State Capitol), where the casket was placed upon an elaborately decorated catafalque and dais. The interior and exterior of the statehouse had been draped with mourning decorations. People were waiting in long lines to pay their respects. (An exhibit in the Abraham Lincoln Presidential Museum recreates the scene of Lincoln's casket lying in the Hall of Representatives.)

Left: Crowds waiting on the north side of the downtown square to see Lincoln's body in what we now call the "Old State Capitol." *Courtesy of the Sangamon Valley Collection, Lincoln Library in Springfield, Illinois.*

Below: Lincoln's funeral train at its final stop in Springfield. *Courtesy of the Sangamon Valley Collection, Lincoln Library in Springfield, Illinois.*

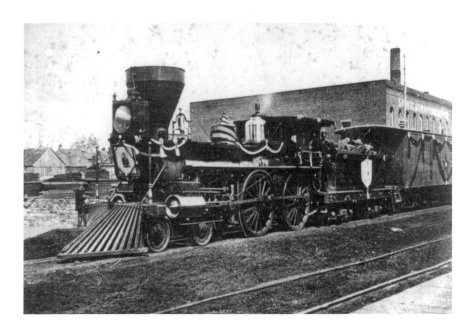

After the silver-fringed, walnut coffin was in place, the hall was locked, and undertaker Thomas Lynch and embalmer Dr. Charles Brown opened the casket, according to Dorothy Meserve Kunhardt and Philip B. Kunhardt Jr.'s *Twenty Days*. Brown had accompanied the body from Washington, D.C., according to Kim Bauer, director of the Lincoln Heritage Project in Decatur, Illinois. Bauer says that Brown carried a special pass giving him access to the body.

When the coffin was opened in Springfield, "even [Lynch and Brown] were shocked," the Kunhardts wrote. Lincoln's face was "totally black." Lynch ran to a nearby store, bought makeup and brushes and spent half an hour touching up Lincoln's face.

"A few minutes past ten o'clock a.m....the vast crowd was admitted to view the remains," the May 4 *Journal* reported. "Had it not been for a slight discoloration of the face it would have appeared as though the martyr had 'fallen into a quiet sleep.'"

For three hours on the night of May 3, only women, children and "their escorts" were admitted to the Hall of Representatives, according to that day's *Journal*. The general public was then admitted until at least 1:00 a.m. About seventy-five thousand people viewed the remains, according to the May 5, 1865 *Journal*.

Many probably wore one of the several styles of mourning badges that local stores were selling at twenty-five or fifty cents apiece, although there was only one "official" Springfield City Council badge, which was available at Smith and Brother's variety store.

"Springfield wears a mournful appearance since President Lincoln was shot," wrote Springfieldian Elbridge Atwood in a May 7, 1865 letter to his sister (the original is in the Abraham Lincoln Presidential Library manuscript collection). "All of the stores around the square and the principles [*sic*] streets are draped in mourning, and the State-House was fixed up in Splendid stile [*sic*], it being draped in mourning clear to the top of the dome."

The *Illinois State Journal*, which was Lincoln's ally, adorned its papers with black, page-long "mourning borders," as it had nearly every day since his death. (However, the *Illinois State Register*, the Democrats' local paper, only printed mourning borders for two days after his death.)

After viewing Lincoln's remains, visitors spent the day wandering the city, looking for places where Lincoln "had lived or worked or done some

particular thing," according to *Twenty Days*. Many went to see the Lincolns' home, which Lincoln had rented to the Lucian Tilton family upon leaving for Washington. Mrs. Tilton, who graciously gave mourners a home tour, estimated that two hundred people came every five minutes, according to the book. Some "begged" for hairs from the Lincolns' horse, Old Bob.

The next day, May 4, banks and bars were closed by mayoral order for the second day in a row. That didn't stop even more people from flocking to town.

"At about 10 o'clock a.m. the coffin was closed, and [Lincoln's] beloved features were shut out from the people forever," noted the book.

Samuel S. Elder, a local tinsmith, spent the next hour and a half soldering shut the coffin, according to Sunderine Temple and Wayne Temple's *Illinois' Fifth Capitol*. They wrote that Elder considered that day's work "sacred" and never billed the state for it.

During this time, a 250-member choir and 20-member St. Louis band performed "Peace Troubled Soul" on the steps of the statehouse. As the coffin was placed in the hearse, they sang "Children of the Heavenly King," according to the *Journal*.

"The coffin…was covered with flowers, among which was those wrought into the form of a cross, presented by the Ladies Aid Society of this city, and a very beautiful evergreen crown," the paper added.

A long procession of local, state and federal dignitaries, friends, a few relatives, clergy, Lincoln's doctors and military units escorted the hearse to Oak Ridge Cemetery. In the middle of the procession was Old Bob, the Lincolns' horse, escorted by Reverend Henry Brown, a black man who had worked for the family, according to *The History of Sangamon County*. At the end of the procession, according to the May 5 *Journal*, were "citizens at large" followed by "colored persons," which included Lincoln's friend and barber William Fleurville.

At the cemetery, Lincoln's $1,500 coffin was placed in a public receiving vault while a choir sang. Beside it was placed the coffin of his son, Willie, who had died at the White House. Several clergy spoke, one read Lincoln's last inaugural address and the choir sang a dirge composed for the occasion, "Farewell Father, Friend and Guardian."

Only one of Lincoln's immediate family members was there. Robert, his oldest son, had arrived in Springfield the night before. Lincoln's private secretary, John Nicolay, accompanied him, the May 4 *Journal* noted.

Mary was in Washington, grieving, according to Bauer. "She was so depressed and despondent that she could not bear to be present during any of the funeral ceremonies including the one [on April 19] in Washington." Their only other living son, Tad (sons Eddie and Willie had died by this time), stayed with Mary in Washington, according to Bauer.

While many were deeply moved by Lincoln's hometown funeral, one Springfield woman thought otherwise. New Englander Sarah Sleeper and her husband had been living in Springfield for a couple years when she wrote to her mother in New Hampshire on June 16, 1865 about the events (her letter is located in the Abraham Lincoln Presidential Library manuscript collection):

> *Such a time as there was here at old Abe's funeral. I think it's wicked to spend so much money in such a way. I have not heard one person speak well of Mrs. Lincoln since I came here.*
>
> *I saw their house while it was draped in mourning, 'tis quite a pretty place. Their old buggy horse was "rigged up" in black and led in the procession by a "nigger." How foolish. Bob Lincoln did not appear very sorrowful—neither did any of the big men from Washington. I didn't either.*

THE BOOTH BROTHERS AND THE LINCOLNS

In 1863 or 1864 (the date is uncertain), one of America's top Shakespearean actors was standing on a train platform in Jersey City, New Jersey. Edwin Booth was on his way to perform at Ford's Theater in Washington, D.C.

While standing on the platform, he happened to see the bustling crowd accidentally push a young man onto the adjacent train track. There was a train on the track and it began to move—toward the man.

Edwin "grabbed the young man by the collar and yanked him up onto the platform," according to historian Jason Emerson (author of *The Madness of Mary Lincoln*), who has researched this incident extensively. The young man recognized Edwin and thanked the famous actor.

At the time, Edwin had no idea whom he had saved. It could have been anybody. He didn't learn the young man's identity until 1865, according to Emerson—a pivotal year in the lives of the young man and his lifesaver, because that year Edwin's younger brother murdered the young man's father.

The young man was Robert Lincoln, son of Abraham Lincoln. Edwin was the brother of John Wilkes Booth, Lincoln's assassin.

By 1865, Robert was serving in the army. He told his friend, General Adam Badeau, about how Edwin had saved him. Ironically, Badeau was a friend of Edwin's. Badeau wrote him that the mysterious young man he had saved was the son of the president Edwin admired so much.

Emerson doesn't know exactly when Edwin learned Robert's identity in 1865, but he believes it was before Lincoln's assassination. Edwin was devastated by that event. He had adored and voted for Abraham Lincoln, and was crushed that his own brother had killed him. He gave up acting for about a year out of despair and fear that audiences would revile him because he was a Booth.

Over the years, Robert told a few others the story of how Edwin saved him and several of those accounts were published, according to Emerson, who is working on a biography of Robert to be published by the Southern Illinois University Press. In one account, Robert wrote that "Mr. Booth saved me from serious injury, if not worse."

After his brother killed the president, remembering that he had saved Robert comforted Edwin, Emerson says. One of Edwin's good friends wrote an article about him in the November 1893 *Century* magazine, saying that the incident was one of "only two things that allowed Booth to maintain his sanity in the aftermath of the assassination."

For his part, Robert recognized the incident's irony. An acquaintance of his said Robert once commented that "it certainly was a strange coincidence in view of later events," according to Emerson.

The ironies didn't end there.

After a year's hiatus from the theatre, Edwin resumed his theatrical career and traveled around the United States and European countries performing. Three different accounts say that he performed in Springfield at Rudolph's Opera House, also known as the Rudolph Theater, which was in business for several years after it opened in 1866. (It wouldn't have been unlikely for Booth to appear here—from that time through the 1880s, Springfield attracted some of the nation's top talent.)

What must it have felt like for Edwin to come to the hometown of the man he admired—a man his own brother killed? If he knew what became of the land where he had performed, surely he would have been comforted.

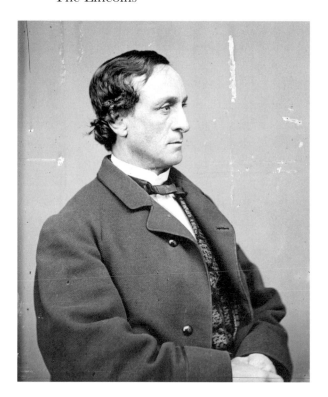

Edwin Booth between 1855 and 1865. *Courtesy of the Library of Congress Brady-Handy Photo Collection.*

Rudolph's Opera House was located at the southeast corner of Sixth and Jefferson Streets, where the Abraham Lincoln Presidential Library is located today.

THE BLOODSTAINED DRESS

Laura Keene played many roles in her life, but the one for which she's remembered is comforting Abraham Lincoln after he was shot on April 14, 1865.

Keene was a talented actress and theatre pioneer, according to *Laura Keene: Actress, Innovator and Impresario* by Ben Graf Henneke. She was the first woman in America to manage a theatre company, and she developed business methods still used today.

However, these accomplishments were largely forgotten after that night.

Keene's company was performing the comedy *Our American Cousin* on April 14 at Ford's Theater in Washington, D.C. As usual, she had the leading role.

Lincoln and his entourage arrived late. When the audience saw him, it applauded, and the orchestra struck up "Hail to the Chief." From the stage, Keene curtsied to the presidential box.

While the audience was laughing at a joke in Act III, John Wilkes Booth snuck inside and shot the president. Keene had been offstage, but as chaos took over, she came onstage and pleaded for calm.

After someone requested water for the president, she weaved through the crowd with it. Upon entering the presidential box, Keene saw Lincoln on the floor. As doctors waited for him to rouse, Keene "sank to the floor...and, pillowing [Lincoln's] head in her lap, she bathed the temples with the water," Henneke wrote.

A local lawyer named Seaton Monroe was in the audience and wrote about the sight. Henneke quoted him: "[Keene's] hair and dress were in

Actress Laura Keene between 1855 and 1865. *Courtesy of the Library of Congress Brady-Handy Photo Collection.*

disorder, and not only was [her] gown soaked in Lincoln's blood, but her hands, and even her cheeks where her fingers had strayed, were bedaubed with the sorry stains!"

When Keene's daughter visited her the next day, the actress was literally shaking. She showed her daughter the stained costume from the night before, and the daughter later wrote that "even [Keene's] underskirts" were bloodstained.

A year and a half later, in the fall of 1866, Keene played in Chicago, Peoria and Springfield. What's odd, by today's standards, is that none of these town's major papers interviewed Keene about the assassination or dress. Was that out of courtesy for her or Lincoln? Did she refuse to speak about it? Even Springfield's papers, which reported minutiae about Lincoln's assassination and funerals, only ran promotions and reviews of Keene's local shows.

She was in Springfield for about a week, beginning on November 6, 1866. While here, Keene visited the temporary vault in Oak Ridge Cemetery that held Lincoln's coffin and left a swatch of her "Lincoln" dress, according to some accounts. That piece is now one of two alleged Keene dress swatches in the Abraham Lincoln Presidential Library and Museum in Springfield. Bryon Andreasen, research historian at the ALPLM, says, "Unfortunately there were no universally accepted professional standards for documenting artifact acquisitions [then]. People just wrote notes or transmitted information orally."

The museum has "several handwritten notes" about Keene's swatch and they "appear to be written in the nineteenth century," Andreasen says. One reads: "Brought to Springfield by the Actress and placed in the office of Oak Ridge Cemetery, November 9, 1866." Another reads: "Presented by John Carroll Power, Custodian of the National Lincoln Monument, May 30, 1877." Others, which may have been used in a display of the dress remnant, read: "Piece of the Dress worn by the Actress, Laura Keene, The evening he was shot" and "Presented by Laura Keene."

"The most likely scenario," Andreasen says, "is that Laura Keene presented the dress remnant to members of the National Lincoln Monument Association in Springfield who, in 1866, were still in the early stages of raising money and planning the monument that would become the Lincoln Tomb."

After the assassination, Keene's dress was a curiosity—possessing nearly as much star power as she did. Actors and the public asked to see it—or

touch it or buy it or exhibit it. She refused. People created fake Keene dresses or swatches that they displayed and sold. Some even forged her name to authenticate the imposters.

"At some unspecified time," Henneke wrote in his book, Keene tired of the mess and shipped the dress to its maker—Jamie Bullock in Chicago.

Supposedly, Bullock didn't know he had "the Lincoln dress" until 1873, when Keene, deathly ill, wrote him to bequeath it to her daughter. When Keene's daughter died, she passed it to her daughter, Clara. "Clara is supposed to have distributed panels of the dress to friends sometime about 1890," Henneke wrote. But Keene may have given away other pieces, as well.

It's too bad that we don't have a Springfield newspaper article or Keene journal to tell us more about when she left the swatch here and how she felt about visiting Lincoln's hometown.

Perhaps someday a document will pop up to tell us the rest of the story.

THE STRANGE TALE OF LINCOLN'S SON, THE SECRET SERVICE AND STUPID CRIMINALS

In 1876, some bumbling boobs from Chicago tried to kidnap Abraham Lincoln's body from his tomb in Springfield's Oak Ridge Cemetery. Their brazen plan was shocking enough, but what's more surprising is that Lincoln's son, Robert Todd Lincoln, knew about the plan and let it proceed.

This is the crazy story of inept grave robbers, a disorganized federal government and Lincoln's oldest son, who was burned by both.

The grave robbing was originally scheduled for the Fourth of July, according to *The Collected Writings of James T. Hickey*. "Big Jim" Kinealy, head of a midwestern counterfeiting gang, planned to steal Lincoln's body, hide it in a "large, hollowed-out log" near Mount Pulaski and ransom it. However, Kinealy had to scrap the plan after a loose-lipped crony told a Springfield prostitute and she informed police.

That wasn't the end of it, though. Kinealy co-owned a Chicago bar, the Hub, with John Hughes, another big counterfeiter. Hughes and his cohorts were "running out of money, both good and bad," says Nan Wynn, former site manager at the Lincoln Tomb. So they decided to resurrect Kinealy's plan.

John Carroll Power, the caretaker of Lincoln's tomb during the botched attempt to kidnap Lincoln's body, wrote a book about the incident. *Courtesy of the Sangamon Valley Collection, Lincoln Library in Springfield, Illinois.*

"The idea was they'd steal Lincoln's body and take it to the sand dunes at Indiana, near Lake Michigan, and let it bury itself. The shifting sands would obliterate their tracks, so there'd be no way to find the body. They'd use natural landmarks to figure out where it was," she says.

"They'd have one person posing as an innocent bystander who would notify Illinois' governor of the kidnapping and negotiate the return of the body for $200,000 and the release of their jailed engraver," according to Wynn.

The counterfeiter who was set to play the "innocent bystander" was delighted. He thought that "he would be hailed as a public benefactor" after Lincoln's body was returned to the Lincoln Tomb, wrote then tomb curator George Cashman in the May 1, 1965 *Illinois State Register*.

Luckily, the federal government was one step ahead of the crooks, which may not say much. A government informant had infiltrated the gang and told the Secret Service about its plan.

Then the Secret Service told Robert Lincoln. For many years, people assumed that Robert asked the Secret Service to help foil the counterfeiters, but the opposite is true.

"[The Secret Service] asked [Robert's] permission to allow the crime to take place so that the counterfeiters could be arrested, questioned, and imprisoned for their counterfeiting activities," according to Hickey's book. This became known only after Robert Todd Lincoln's papers were opened decades later at the Illinois State Historical Library, which became the Abraham Lincoln Presidential Library. Those letters chronicle his difficult relationship with the federal government in this boondoggle. One of Robert's letters states that he felt obligated to cooperate with the Secret Service out of appreciation for being informed of the body-snatching plan.

According to the May 29, 1938 *Chicago Tribune*, the would-be grave robbers planned to kidnap Lincoln's body on November 7, 1876, figuring that Springfieldians would be in town awaiting results from the fierce election and away from the tomb, which was on the city's outskirts at that time.

That's about the only thing they got right.

On November 6, the counterfeiters took the train to Springfield, with Secret Service agents secretly tagging along. The next day, they visited the Lincoln Tomb, "asked questions of [the custodian], and departed after signing false names to the [visitors] register," the *Tribune* related.

That night, the group, including the federal informant, returned to break in. Back then, Lincoln's coffin was housed in a large marble sarcophagus in the burial chamber at the back (or north) side of the tomb. That's where Lincoln's tombstone is located now. Unlike today, there were no halls inside the tomb. Instead, visitors walked outside of the tomb to view the sarcophagus through an opening, which was protected by an iron gate. "The counterfeiters just needed a tool to break through the gate," Wynn says.

They brought a hacksaw for the job, but it broke. So they used a file, which was not up to the task; it took half an hour, according to Thomas J. Craughwell's book *Stealing Lincoln's Body*.

After a long delay, broken tools and a lot of improvising, they made their way into the burial chamber, opened the sarcophagus and pulled the coffin out about eighteen inches, Wynn says.

Then the gig was up—or it should have been.

Secret Service agents were hiding nearby, waiting to rush the grave robbers after their informant signaled that the sarcophagus was open. However, the informant had been sidelined when the criminals' tools broke.

"It had to have been like the Keystone Cops," Wynn says.

The agents waited and waited. Finally, their informant came out, supposedly to retrieve the getaway vehicle (a horse and buggy), and signaled them.

They ran into the burial chambers, but it was too late—the criminals were gone. The counterfeiters were waiting outside the tomb, hidden beneath trees, according to Cashman's article.

When the grave robbers saw the Secret Service agents, they ran. One account says the Secret Service agents engaged in a short gun battle, mistaking one another for the criminals.

"It wasn't until a few days later that [the criminals] were apprehended back at their drinking establishment in Chicago," says Wynn.

Unfortunately, the Secret Service didn't have much of a case. They "had no evidence" to charge the criminals with counterfeiting, Hickey wrote. Officials considered charging them with grave robbing or damaging a monument, but at the time those weren't considered big crimes and the punishments were light. The best they could do was charge the men with robbery—attempted theft of a casket.

Now the story gets *really* odd.

The counterfeiters were considered a flight risk because they needed money, their trial likely wouldn't take place for a while and their bails had been reduced to affordable levels. So the Secret Service again asked Robert Lincoln for help, according to his letters.

Robert agreed to secure and pay a top-notch lawyer to try the case and pay the counterfeiters a daily fee of $2.50 not to flee. The federal government would then reimburse Robert. While Robert fulfilled his promise, the federal government did not.

Despite Lincoln's numerous letters to various government officials, there is no evidence that they ever repaid him, Hickey wrote, and Lincoln's letters indicate the same.

"I could have stopped this scheme with little trouble and no expense, but allowed it to go on at their request," he wrote his friend, U.S. Senator David Davis. "Now they leave me in the lurch."

Lincoln had spent $643, not a paltry sum in the late 1800s, and the bad guys weren't even charged with counterfeiting. At least a grand jury found them guilty of conspiring to commit theft. The two-day trial took place in late May, more than six months after the foiled crime. Each counterfeiter was sentenced to one year in the state prison.

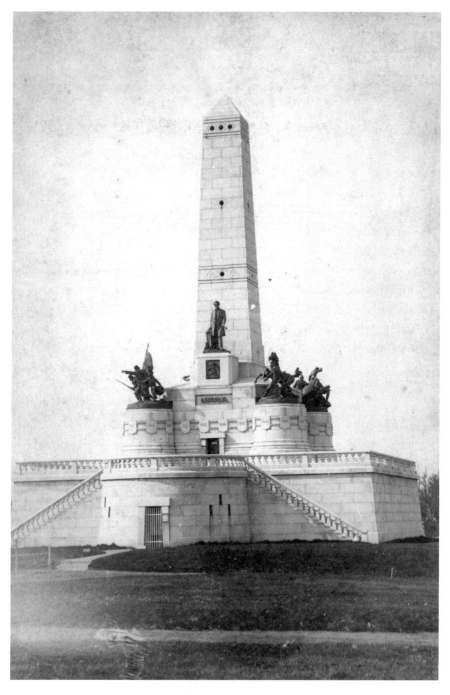

When the kidnappers tried to steal Lincoln's body, they had to break through the north side of Lincoln's tomb. This is its south side. *Courtesy of the Sangamon Valley Collection, Lincoln Library in Springfield, Illinois.*

According to a May 29, 1938 *Chicago Tribune* article, the mastermind of the plot, "Big Jim" Kinealy (who wasn't present at the botched kidnapping), was never charged or sentenced for it. Later, he was jailed for counterfeiting.

MARY LINCOLN COMES HOME

September 11, 1875, had to be a bittersweet day for Mary Lincoln. After a fifteen-year absence, she was returning to Springfield, where she and Abraham had raised their children and where he had been elected president.

She left as a first lady but came back a "crazy" woman.

Mary had just been released from Bellevue Place Sanitarium, a private insane asylum in Batavia, Illinois, where she had been placed in May 1875 after being judged insane at a trial initiated by her only living son, Robert.

Since leaving Springfield, Mary had nursed two sons until their deaths (a third had died here earlier), seen her husband's brains blown out, lost relatives in the war, spent money lavishly, traveled fitfully, run from supposed assassins, tried to commit suicide and been locked away.

Now, thanks to her and her friends' lobbying, she was somewhat free. She returned to Springfield to see her sister and brother-in-law, Elizabeth and Ninian Edwards. (They lived in a brick mansion on a lot where the Howlett Building is located, on the northwest corner of Second and Edwards Streets.)

A few months after arriving at Bellevue, Mary asked two powerful Chicago friends to help her get out of there, according to Jason Emerson, a Virginia historian. He made an historic discovery in 2005 when he found letters from Mary and others from this period that were thought lost. He used them to give new insight into Mary's so-called insanity period. The result was his book *The Madness of Mary Lincoln*.

"The letters show that Mary Lincoln enlisted the help of Myra and James Bradwell to visit the Edwards' home in Springfield—the first letters [which date to July 30, 1875] specifically state Mary wanted to visit the Edwardses, not go and live with them," Emerson says. "Of course, later, after she had been there a few weeks, that visit turned into a relocation."

He continues: "In one letter, Mary tells Myra Bradwell to write [Mary's sister, Elizabeth] and 'beg and pray her as a Christian woman' to write to [Mary's son] Robert about allowing [Mary] to visit Springfield…She also asks

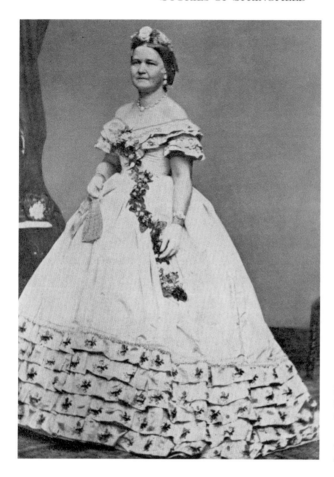

Mary Todd Lincoln during happier times. *Courtesy of the Sangamon Valley Collection, Lincoln Library in Springfield, Illinois.*

Myra to contact Mary's younger sister, Ann Todd Smith, and her husband, Clark Moulton Smith, one of Springfield's most successful merchants, for their help."

It worked.

Four months after Mary had been placed at Bellevue, Mary's son Robert, the asylum's physician and a psychiatric expert whom Robert hired grudgingly consented to Mary being released to the care of the Edwardses, according to *The Insanity File* by Mark E. Neely Jr. and R. Gerald McMurtry.

Before he consented, the psychiatric expert, Dr. Andrew W. McFarland (who ran a private asylum in Jacksonville at the time), examined Mary and wrote to Robert that he feared sending her to the Edwardses would not work "unless the utmost quietude is observed for the few ensuing months, beyond

which all reasonable hope of restoration must be abandoned, unless success within that period is achieved," the book noted.

McFarland also recommended that Mary have a nurse companion. Mary's sister, Elizabeth, requested it be a "competent, white person," according to Jean H. Baker's *Mary Todd Lincoln: A Biography*. That person was Anna Kyle, whom McFarland recommended, although she only lasted one month.

Springfield's newspapers quietly noted Mary's return.

On September 11, the *Illinois State Register*, Lincoln's political opponent, said Mary and Robert had arrived as "guests of Honorable N.W. Edwards." Robert would return to Chicago immediately, the paper added, but "Mrs. Lincoln will remain here for the present."

However, Lincoln's close ally, the *Illinois State Journal*, was more generous:

> *The public will be deeply interested to learn that Mrs. Abraham Lincoln, with her son, Robert, is expected to arrive in this city this morning, on a visit to her sister, Mrs. N.W. Edwards. As the state of her health renders quiet and seclusion of the first importance, we are certain that the sympathy of our citizens, while it will not diminish their interest, will prompt the utmost consideration and delicacy of treatment.*

A few days later, on September 15, the *Journal* gave an update:

> *The friends of Mrs. Lincoln will be gratified to learn that, since her arrival in this city, she has manifested much of her usual cheerfulness, and evinces much gratification in meeting old friends, many of whom have called upon her. She rides out frequently and takes a deep interest in the changes manifest since she was familiar with Springfield.*

The following June, a new trial was held, and Mary was judged sane.

She stayed in town until the end of that summer (in 1876), according to *The Insanity File*. "Although [her sister] Elizabeth continued to argue that [Mary] should at least make Springfield her headquarters, Mary said that the town held too many sad memories."

Mary traveled America and Europe but returned to the Edwardses as an ill woman in 1880. She died in their house on July 15, 1882.

THE FIRST ABRAHAM LINCOLN
PRESIDENTIAL MUSEUM

When the current Abraham Lincoln Presidential Museum opened, it was heralded as the first of its kind. However, there was an unofficial predecessor located in the Lincoln Home between 1884 and 1893. It was run by Civil War veteran Osborn Hamiline Ingham Oldroyd, a man as quirky as the museum he created. (His initials spelled out the name of his native state, Ohio.)

Oldroyd began collecting items related to Lincoln in 1860—"books, sermons, eulogies, poems, songs, portraits, badges, autograph letters, pins, medals, envelopes, statuettes," Oldroyd wrote. However, he was as much historical huckster as hero.

The Lincoln fan found his calling in 1880 while attending services at the Lincoln Tomb on the fifteenth anniversary of the president's death. "As I gazed on the…resting-place of him whom I had learned to love in my boyhood's years…I fell to wondering whether it might not be possible for me to contribute my mite [sic] toward adding luster to the fame of this great product of American institutions," wrote Oldroyd in his book, *The Lincoln Memorial: Album-Immortelles*, published two years later. He developed a plan: he would build a Memorial Hall in Springfield to display his collection.

Oldroyd assembled his book to raise money for the hall. It contained snippets of Lincoln's speeches and writings, as well as reminiscences of the president that Oldroyd sought from Lincoln's peers. Sales were fairly good, according to Wayne Temple's book, *By Square & Compass: Saga of the Lincoln Home*, but he never constructed Memorial Hall.

He ran a succession of failed businesses and moved his family closer and closer to the Lincoln Home, according to Temple. In 1883, when the Lincolns' old house became available to rent, Oldroyd moved his family in before the last occupants had completely moved out.

At that time, Lincoln's oldest and only surviving son, Robert, owned the home. He charged Oldroyd twenty-five dollars in monthly rent.

Oldroyd arranged his nearly two thousand Lincoln items on the home's first floor (his family lived on the second), and on April 14, 1884—the nineteenth anniversary of Lincoln's shooting—he opened his museum. Admission was twenty-five cents, according to a 1992 Lincoln Home Historic Structure

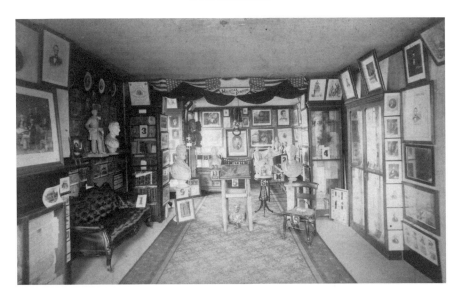

This 1884 photo shows the "cabinet of curiosities" that Oldroyd established in the front and back parlors of the Lincoln Home using some artifacts directly related to the Lincolns. The black sofa on the left is still in the home. *Courtesy of the Lincoln Home National Historic Site.*

Report. (Later in life, Oldroyd denied ever charging admission, according to Temple's book.)

"The reception at the Lincoln residence last night was a brilliant affair," reported the next day's *Illinois State Journal*. "Mr. Oldroyd has been at work for years on this matchless collection, and it is believed its equal does not exist in the United States."

Oldroyd found creative ways to publicize his museum and meet the public's desire for Lincoln artifacts. He sold photographs of his collection for twenty-five cents and a box of "Lincoln relics" for seventy-five cents.

The box contained bits of the Lincoln Home and grounds: pieces of brick, shingle, ceiling plaster, elm tree, apple tree, lath, joist and floor, according to James Hickey's article "Own the House Till it Ruins Me."

Two years after Oldroyd moved into the home of the man he adored, he began stiffing the man's son. Oldroyd stopping paying rent in 1885, according to Temple. Robert Lincoln, reluctant to raise public attention to the matter, didn't pursue legal proceedings against the "dead beat," as he called Oldroyd in a letter, even two years and no rental payments later.

In this circa 1890 photo, Osborn Oldroyd stands outside of the Lincoln Home, which was owned by Lincoln's son, Robert. Oldroyd stiffed him on the rent. *Courtesy of the Lincoln Home National Historic Site.*

Robert felt that he was being used, and "he was not happy with the way Oldroyd had turned the home into a sort of carnival sideshow, selling pieces of it and putting other things into it that had not been the Lincolns'," says James Cornelius, curator at the Abraham Lincoln Presidential Library and Museum.

While Oldroyd wasn't paying rent, he was also working on a way to live in the home officially rent-free. Hickey's article explains how Oldroyd "quietly" lobbied Illinois legislators to acquire the Lincoln Home for the state and let him and his museum remain in it. In 1887, Oldroyd got his wish. He was appointed the home's custodian and paid $1,000 a year. There is no evidence that Oldroyd ever paid Robert the two years of back rent.

In 1893, political winds shifted, and Oldroyd was ousted. The new Democratic governor put one of his own into Oldroyd's position. So Oldroyd found a new home for his "museum."

He took his collection to Washington, D.C., and set it up in the Petersen House, the home across from Ford's Theater, where Lincoln died. This time he actually paid rent, according to Temple.

The problem was the museum featured pilfered artifacts. "He pretty much cleaned house" when he moved out of the Lincoln Home, says Susan Haake, curator of the home. She says he took at least twenty-five items from the home that were the state's, including "important pieces" such as the heavy, cast-iron stove that Mary loved and the cradle that the three youngest Lincoln boys had used.

"By the time Oldroyd had been removed as custodian, the home had suffered irreversibly significant damage," noted the home's 1992 Historic Structure Report. "After Oldroyd, the Lincoln Home would truly never be the same home known by the [Lincoln] family."

Justice was done decades later. Between the 1950s and late 1980s, the Lincoln Home got twenty-five items back that Oldroyd had "taken," says Haake. "For the most part, [the items] are in wonderful shape."

"Oldroyd felt he was doing a public service," Haake says. "In reality he was, because this stuff wasn't really valued [during his time]. The fact that Oldroyd was saving all these Lincoln items probably did save a lot of them from being used until they were worn out."

"In truth, O.H. Oldroyd had made a most significant contribution to the history of Lincoln," wrote Temple. "Even though [his book on Lincoln] contains flowery platitudes, a few of Lincoln's close friends wrote wonderful reminiscences for [it]. No serious Lincoln scholar today can afford to ignore this work."

AFRICAN AMERICANS

EARLY AFRICAN AMERICANS

When studying the history of Springfield or many towns, it's easy to find information about white settlers. Learning about minority groups, though, is another story.

There's less information about them for several reasons. They were deemed second-class citizens in the 1800s and early 1900s, they weren't the majority and they didn't write the histories; in fact many couldn't read or write.

Some were indentured servants and slaves, even while they lived here, according to local historian Richard Hart, who has studied the city's early African American population extensively and written about it in his article "Springfield's African Americans as a Part of the Lincoln Community" and his booklet *Spirit of Springfield's Early African-Americans (1818–1859)*.

It's hard to find much 1800s material written about Springfield's African Americans. One of the first accounts is found in the 1881 *History of Sangamon County* in an eight-page section called "The Colored People of Springfield."

"There was a time in the history of Springfield, when the face of a colored man or woman was a rare sight," it begins. "Before the deep snow [the unusually bad winter of 1830–31], old Aunt Polly, a colored woman, reigned supreme in Springfield."

Hart, however, found that the first black person in the city was an enslaved boy called "Negro Jack," who came here with his owners in 1819, long before

"Aunt Polly." The very first African Americans that came to Springfield were slaves brought here by their owners, according to Hart's research. He found that even Mary Todd Lincoln's uncle, Dr. John Todd, had slaves here—five of them.

The 1881 *History* does not mention that. It traces African Americans' movement here to the Civil War. "It was not until and after the war that the race made their advent here in large numbers," noted the book. "The first installment of 'contrabands' that arrived while the war was in progress were almost as much objects of curiosity as the first that came. But time has passed and the colored people of Springfield form an important factor of it."

The 1881 *History* profiles twenty-five of those blacks, which it says "represent only a few of the large number of [African Americans] who reside here, but those selected…are from the best class of the colored race; many of whom are fairly educated."

The men and one woman profiled included a handyman for Abraham Lincoln, Civil War soldiers, ministers, an usher for the governor, farmers, barbers, a restaurateur, a widow and more.

Reverend Henry Brown's story is one of the highlights. He was born in North Carolina in 1823, "bound to a family of Quakers at 14," married to a woman who died the next year, licensed to preach at twenty-four, came to Springfield about that time and at some point became a handyman for Lincoln. "In 1865, when Mr. Lincoln's remains were brought to Springfield, Mr. Brown…led Mr. Lincoln's old family horse, 'Bob,' in the funeral procession," the book noted.

Another African American Springfield minister, George Brent, was a former slave. His father, also a slave, "in some manner" secured his own freedom, then "enlisted the sympathies of eight persons," and they "signed a note for the sum of $1,200 to purchase" George's freedom, according to the 1881 *History*. They paid the note in one year "and insured the life of George to secure them from loss in case of his death." George repaid them in three years by blacksmithing.

He and his wife had thirteen children, though only five lived. Two of their children were killed by lightning. George paid a coworker five dollars to teach him to read. He also learned to write. About 1865, he bought a home in Springfield and became pastor at the Zion Baptist Church.

William Head, who was born in 1822, was "kidnapped by a slave ship" at the age of eight and taken to New Orleans. He was a slave for ten years. During the Civil War, he became a "body servant" for a colonel and was "struck by a piece of shell" at the Battle of Shiloh "while carrying Colonel Morgan from the field, breaking both his legs." He ended up in Springfield, where he opened a restaurant at Eleventh and Mason Streets. Head must have done well; the 1881 *History* authors made a point of adding that he owned his "business building, his large and commodious residence, and two lots adjoining."

Other African Americans who came to Springfield in the mid-1800s included barbers (see the story about "Billy the Barber" on pages 82–92), Underground Railroad conductors, maids and cobblers, among many others.

SPRINGFIELD'S UNDERGROUND RAILROAD

Historical records suggest that at least a half dozen Springfieldians helped slaves escape north through central Illinois on the Underground Railroad (UGRR), but there's so much we don't know about the UGRR. That's part of its intrigue—we'll never know the whole story. Its activists tried to keep their work secret, so there are no official records. (Many African American participants couldn't read or write, so they didn't leave documents.) What we know comes from oral histories, journals and memoirs sometimes found by luck.

The UGRR was secret because participants took enormous risks. By law, they were criminals. Official and vigilante punishment, even death, faced those who were discovered.

"I became so well known to the slave catchers, who used to congregate about St. Louis, that for years I would not have visited that city for any amount of money," said Benjamin Henderson in Charles Eames's *Historic Morgan and Classic Jacksonville*. Henderson was a former slave and Jacksonville UGRR conductor who brought slaves to Springfield. "It is now rather a matter of pride to be reckoned among the abolitionists of those days, but it was not so then," he said.

Henderson described another Jacksonville UGRR conductor, Dr. M.M.L. Reed, whose activism "cost him daily in a financial way, beside endangering

his life and greatly destroying the peace of his family." Henderson said Reed was so hated by slavery supporters "that for years he seldom felt safe in walking on the sidewalk at night, taking the street to avoid a possible unseen enemy…One night during his absence his family had reason to believe an unsuccessful attempt was made to set his house on fire."

How, and even if, the UGRR operated in a given area was determined by its political makeup.

Politically, Illinois was a land of opposites. Southern Illinois was largely proslavery thanks to the many southerners who moved there. "The southeastern part of Illinois contained few or no [UGRR] lines," wrote renowned UGRR researcher Wilbur Siebert in his 1898 book *The Underground Railroad from Slavery to Freedom*.

Abolitionist Seth Concklin, who died helping slaves escape the South, wrote this passage in 1851 and is quoted in William Still's *The Underground Rail Road*:

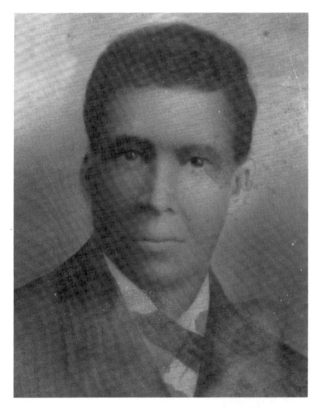

William Donnegan allegedly helped many slaves escape north to freedom through Springfield. *Courtesy of the Sangamon Valley Collection, Lincoln Library in Springfield, Illinois.*

Searching the country opposite Paducah, [Kentucky] *I find that the whole country fifty miles round is inhabited only by Christian wolves. It is customary, when a strange Negro is seen, for any white man to seize the Negro and convey such Negro through and out of the State of Illinois to Paducah, Ky., and lodge such stranger in Paducah jail, and there claim such reward.*

As you moved north in Illinois, the sentiment morphed into abolitionism. "[In Chicago] the slave was virtually safe, for he was not only assured of protection from white people, but the Negro element was strong enough to prevent his capture. The colored population did not hesitate to resist officers of the law and slave holders," wrote Verna Cooley in *Illinois and the Underground Railroad to Canada.*

Springfield, in the middle of the state, was a mix of abolitionist and proslavery feeling.

Many fugitives escaped to Illinois from Missouri, where slavery was legal, according to Glennette Tilley Turner's *The Underground Railroad in Illinois.* They entered Illinois through Alton, Quincy or Chester. Fewer came through Cairo, which was more dangerous because of local slavery supporters.

Slaves usually came to Springfield directly from Jacksonville or Farmingdale (then called Farmington). Both towns were known for their abolitionist views and had UGRR participants. (The Illinois Anti-Slavery Society even held its first anniversary meeting in Farmington.)

"In 1841 these fugitives from slavery first began to come through Jacksonville and from that time this has always been a station on the UGRR," said Julia Carter, the daughter of Jacksonville conductor Elihu Wolcott, in the February 4, 1906 *Jacksonville Daily Journal.* "Ben Henderson, among the colored people here, was the one to whom they all went."

Henderson related some of his experiences in *Historic Morgan and Classic Jacksonville.* He said he worked on the UGRR from 1841 until 1857 or 1858.

"A fine looking couple once asked me for shelter," he said.

In great haste. The hunters were hard after them and $1,000 reward was offered for their capture and return. I was then closely watched and hardly knew what to do. Finally I made an excuse to take some hemp cradles to Springfield, so I laid some hay in the bottom of the wagon, put my

passengers on it, more hay over them, and my cradles on top of it and drove leisurely through town about the middle of the afternoon and got through all right.

During the winter of 1853–54, another African American from Jacksonville, David Spencer, transported eight runaways via the Great Western Railroad (his story is also from *Historic Morgan and Classic Jacksonville*). They boarded the train at Jacksonville "just before daylight," Spencer said.

When asked several times who my companions were I replied that they were friends from Chicago who had been here to spend the holidays. Soon after we started one of the men whispered in my ear that his old master was in the car a few seats ahead of us, no doubt on the hunt for his property. I told him not to be afraid, for I had a revolver with me and would use it if I had to do so. To our great relief, the slaveholder left the train at Springfield, little thinking who had been riding with him.

Once slaves reached Springfield, who took care of them?

Local attorney and historian Richard Hart researched that question extensively and published the results a couple years ago in *Lincoln's Springfield: The Underground Railroad*, available from the Sangamon County Historical Society at 308 East Adams Street, Springfield.

Hart found that two white men and four black men from Springfield were UGRR conductors. One of the white men was Luther Ransom, who'd been active with the UGRR in Farmington before moving to Chatham and then Springfield. He ran a boardinghouse near the Globe Tavern (on West Adams), where Abraham and Mary Lincoln lived when first married.

Erastus Wright was the other white man. He lived near Jefferson and Walnut Streets and was a teacher, Sangamon County school commissioner and member of the Second Presbyterian Church, known as "the abolitionist church," according to Hart. It's now called Westminster Presbyterian Church. Other members of that church helped the UGRR, too, according to church history.

Out of the four black UGRR conductors Hart found, three had ties to Abraham Lincoln.

Jamieson Jenkins was his neighbor, living just south of the Lincolns on Eighth Street. A series of articles in the *Illinois State Register* and the *Illinois State Journal* from mid-January 1850 linked Jenkins, a "drayman" (wagon operator), to a group of runaway slaves who escaped through Springfield and suggested that he may have helped them. Jenkins was a member of "the abolitionist church" until 1851.

Reverend Henry Brown worked for the Lincolns as a laborer and led Lincoln's horse in his Springfield funeral procession. Hart found that he had helped escaped slaves in Quincy and Springfield.

Aaron Dyer didn't have ties to Lincoln, but Hart notes his other interesting connection. His grandson, William Dyer, became friends with renowned writer William Maxwell, who grew up in Lincoln. Maxwell wrote a short story about Dyer, who talked about his grandfather Aaron's UGRR work in Springfield. He said that Aaron, a blacksmith and drayman, "drove his horse and wagon at night, taking runaway slaves to the next underground station."

William Donnegan probably has the most interesting, and tragic, story of Springfield's UGRR workers. He was a shoemaker and Lincoln was a customer. A few years ago, Curtis Mann, city historian and head of Lincoln Library's Sangamon Valley Collection, found a memoir believed to be Donnegan's that details some of his UGRR experiences. It was published in the May 1898 *Public Patron*, a Springfield literary magazine.

"I lived, in those days [1858], on the north side of Jefferson, between Eighth and Ninth streets, in a story and a half house…and I could show you the garret yet in which many a runaway has been hidden while the town was being searched. I have secreted scores of them," Donnegan said. "When a man unloaded one or more Negroes at my house or at any other station in the night, it was always done then, his name was not asked."

Donnegan described a harrowing experience helping a teenage slave. She wouldn't follow directions and narrowly missed being spotted by her master, who had followed her here. "I knew the house would be watched all night," Donnegan said. "I heard in the afternoon that about thirty men had been engaged about town for that night. A full description of her had been given in the Springfield Register…with an offer of, I think, $500 for her capture."

He bought the girl white gloves and "a white false face…told her what to call me and what to talk about" and how to alter her voice, "so if her master heard her he would not know her."

During the night, Donnegan whisked the disguised slave away, but her master and armed slave catchers tracked the duo and blocked their way. Donnegan outsmarted them by sneaking into a church and then his brother's house. There they dressed the girl as a boy and sent her with a work gang the next day to a nearby abolitionist's.

Fifty years later, Donnegan, then eighty-four, was lynched during Springfield's race riots.

A memoir at the Sangamon Valley Collection at Springfield's Lincoln Library notes that escaped slave Thomas Madison Davis fled to Springfield and helped others do the same. It was written by his son, John, and tells how "Tom" and other slaves were hidden by sympathetic Union colonel John Cook, from Springfield, while he and his troops were stationed in Paducah, Kentucky.

"[Cook] hid the fugitive slaves as long as he could, but finally called them together and told them that Kentucky was not in rebellion against the United States and they had the right to come every day and seek for their slaves," the memoir says. Cook told the men he couldn't "protect them any longer" and put them "on the Illinois side of the river."

The group traveled north and arrived in Springfield on Christmas. Tom lived at 219 North Fifteenth Street with James Henderson Lee, "a good religious man of color" who "had built a house so that any run away slave who wished to live respectably, might have a place to stay, free of charge until he got on his feet," the memoir noted. "He called it 'The Young Men's Aid Society.'"

Famed abolitionist Seth Concklin may have helped slaves through Springfield, too. He knew about the state's UGRR lines, according to an 1851 letter he wrote (printed in *The Underground Rail Road*), describing a route "through Illinois, commencing above and below Alton."

"In Springfield, Illinois, [Concklin] aided fugitives escaping on the Underground Railroad, but seldom acted in concert with others," wrote Betty DeRamus in *Forbidden Fruit: Love Stories from the Underground Railroad*.

Members of Springfield's Zion Missionary Baptist Church came here via the UGRR, according to *The Underground Railroad in Illinois*. And a Springfield black man named "Free" escorted runaways between here and Chicago, according to Delores Saunders's *Illinois Liberty Lines*.

"He nearly met his 'Waterloo' one time when pursuers gave chase and overtook him near Washington, Illinois," she wrote. "He was shot and badly wounded."

The Springfield–Chicago UGRR line was popular, and disguised slaves often traveled along it by stagecoach, Saunders added. "It was a familiar sight to see a Negro man or woman dressed in a long flowing gown, wearing a fashionable hat, heavy black veil and gloves. Carrying 'her' carpet bag and purse, this passenger sat in sedate form…A sign was placed around 'her' neck which read, 'Deaf and Dumb.'"

"There is so much that needs to be understood about the Springfield Underground Railroad, but there aren't many primary materials about it," says Curtis Mann. Unless more materials are discovered, the whole truth will remain a mystery.

BILLY THE BARBER

In the fall of 1831, a twenty-five-year-old Haitian man strolled toward Salem, Illinois (now Lincoln's New Salem State Historic Site—about twenty miles northwest of Springfield). The man was William de Fleurville, and he was looking for a place to settle.

He had fled New Orleans after seeing blacks mistreated in its thriving slave markets and free blacks forced into slavery by kidnappers, according to *They Knew Lincoln* by John E. Washington, who profiled Lincoln's black acquaintances.

As Fleurville approached Salem, he saw "a tall man wearing a red flannel shirt, and carrying an axe," according to *History of Sangamon County, Illinois*.

It was Abraham Lincoln, one of the village's residents.

"Lincoln soon learned that the stranger was a barber out of money," according to the book. "Mr. Lincoln took him to his boarding house, and told the people his business and situation. That opened the way for an evening's work among the boarders."

The next day, Fleurville (sometimes spelled "Florville") left for Springfield, on Lincoln's recommendation, where he opened the town's first barbershop.

After Lincoln moved to Springfield six years later (in 1837), Fleurville, who was nicknamed "Billy the Barber," became his barber, as well as a prosperous businessman and generous philanthropist.

There were few professions open to black men then. Many became barbers, laundry owners, bathing house operators or all three. Fleurville was

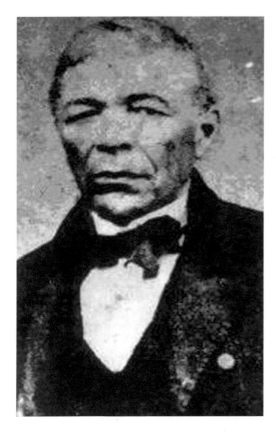

William Fleurville. In 1908, his grandson, George Richardson, was falsely accused of assault by a white woman. The accusation helped ignite that year's race riots. *Courtesy of the Sangamon Valley Collection, Lincoln Library in Springfield, Illinois.*

a savvy businessman. He ran witty and poetic ads in the local paper, such as this one from the September 3, 1841 *Illinois State Register*:

> *Billy will always be found on the spot,*
> *With razor keen and water smoking hot;*
> *He'll clip and dress your hair, and shave with ease*
> *And leave no effort slack his friends to please.*
> *His shop is north-west of the public square,*
> *Just below the office of the mayor...*
> *On Sunday until 9 o'clock he'll shave,*
> *And then to church he'll go, his soul to save...*

Fleurville adorned his shop with "a large collection of paintings and engravings," a November 12, 1841 article noted. These would "amuse and

entertain [a customer's] troubled mind, which will so enliven their spirits that the gloom of dispair [*sic*] will vanish like the dark before the glory of the sun."

His shop "was the 'club house' of Springfield," Washington wrote in his book, after interviewing Fleurville's great-granddaughter. "Every man in Springfield would come to give and hear the latest news. It was packed nearly every evening. This place was Lincoln's second home, and if he could not be found elsewhere, he was sure to be in de Fleurville's shop swapping tales with the owner and other patrons."

Lincoln and Fleurville became friends, and Lincoln served as Fleurville's attorney.

Always savvy, Fleurville didn't want to play political favorites among his friends and clientele. So Fleurville used an upcoming election to his advantage, as demonstrated in a June 14, 1835 *Journal* ad:

> *I am personally friendly to all the candidates…I shall exert myself to secure the election of them all. To effect this object I would say to them that nothing is so necessary as to have "a smooth face." I am adept in making smooth faces. My terms are very moderate. I shall rise in price on some after the election.*

According to Washington, Fleurville charged fifteen dollars for a year of shaving or fifteen cents per haircut (twenty cents for girls).

Legend says that Fleurville was the first black person to arrive in Springfield, but local attorney and historian Richard E. Hart proved otherwise in his article "Springfield's African Americans in the Lincoln Community." He found that thirty-two blacks, including many slaves, preceded Fleurville, the first being "Negro Jack" in 1819.

Fleurville accumulated a lot of property in Springfield, an eighty-acre farm in Rochester and a fair amount of wealth. A devout Catholic, he gave money to the Catholic Church and helped establish the First Christian Church, according to Washington. Hart wrote that Springfield's first Catholic mass was held in Fleurville's home.

Fleurville married Phoebe Rountree shortly after he came to Springfield. They had six children.

His friendship with Lincoln was important, according to Washington. Fleurville's family said "the saddest moment of his life was when he bade

Lincoln good-by [*sic*], after cutting his hair and trimming his beard for the last time," before Lincoln left for Washington, D.C.

After Lincoln died, Fleurville was invited to join a delegation of Lincoln's "local friends" or local "dignitaries" in the funeral procession, but he declined, according to Bryon Andreasen, research historian at the Abraham Lincoln Presidential Library and Museum. Instead, Fleurville walked with the blacks who were relegated to the procession's very end.

Fleurville died on April 14, 1868. He is buried at Springfield's Calvary Cemetery.

"No Rope to Hang Him"

For reasons that historians still ponder, racial tensions erupted in Springfield during the summer of 1908, and the deadly result garnered national attention. Mobs lynched 2 black men, burned blacks' homes and destroyed dozens of black and Jewish businesses. Various reports say 5 white men were also killed in the fighting and 101 whites and blacks injured, though the actual numbers may never be known.

The riots were triggered by two alleged crimes by African American men. One occurred two months before the riots when a black man broke into the bedroom of a well-liked family's teenaged daughter. Her father attacked the man and died from resulting wounds. The other alleged crime occurred one day before the riots broke out; a white woman claimed that an African American man assaulted her.

Two black men were jailed for the alleged crimes, and on August 14, a growing crowd of whites gathered outside the Sangamon County Jail demanding vigilante justice for the victims. Instead, the county sheriff borrowed one of the few cars in town and rushed the prisoners to Bloomington, where they would be safe. Angered, the mob rampaged for two days. The nation was outraged that racial crimes occurred in the hometown of Abraham Lincoln, who freed the slaves.

On a positive note, the riots helped lead to the formation of the National Association for the Advancement of Colored People.

It has been more than a century since Springfield's infamous riots. Rumors about them linger still.

The mob first attacked Loper's restaurant. *Courtesy of the Sangamon Valley Collection, Lincoln Library in Springfield, Illinois.*

Eyewitnesses are long gone, but their memories have been preserved, thanks to the University of Illinois–Springfield, which recorded their oral histories in the 1970s. Oral histories can be tricky because memories aren't always reliable, especially when they are decades old. Nonetheless, eyewitnesses provide a vital and unique perspective—a close-up view of events.

One persistent rumor then and now is that the newspapers didn't report all of the riot-related deaths. Several eyewitnesses commented on that and other aspects of the event.

LeRoy Brown was a black man born here in 1884; he worked as a coachman, caring for people's horses and carriages and serving as their driver. He was twenty-four during the riots and worked for a white family. When he heard that a mob was rioting, he went to his employer's for safety. "He wouldn't let me stay," Brown said, "because they was threatening to burn any of the places where the colored people worked, if they let them come back…Finally, a man by the name of Leach took me, a white man [his employer's neighbor]. He was from Kentucky. He put me in the basement." Brown worked as his coachman for two to three weeks until the situation calmed.

According to Brown, people back then said that "there were lots of white people killed that night, but they carried them out of town and buried [them] someplace."

He saw the mob burn houses "on Twelfth and Madison, all down through there." There were "lots of [black] people," including his brother, who "left town and never came back."

Nathan Cohn was twelve during the summer of 1908, when he saw one man lynched during the riots. "There was a Jewish fellow, and he went out and hollered, 'All white folks hang out a white sheet and put it on their fence,'" he said.

> *There was a lot of white folks following this fellow. This was Thirteenth* [Street], *and then they went west to about Eleventh Street. And they got hold of a colored fellow, and they didn't have no rope to hang him. They wanted to hang him. So whoever was at the head of it looked around at the yard across the street, and he seen a clothesline. So he went across the street and took the clothesline off and hung this guy up. I seen it...Put it around his neck and put it on a tree and just pulled him up.*

That man was Scott Burton, a middle-aged black barber who ran a barbershop for whites, according to the Abraham Lincoln Presidential Library and Museum Race Riot Catalogue. The mob attacked him repeatedly and then lynched him at Twelfth and Madison Streets.

The mob also destroyed Fishman's pawn shop at 719 East Washington; Cohn said it was revenge. "Fishman handled hardware, guns and so forth—the leaders of the gang came in there and wanted him to give them some guns...and he wouldn't do it. But colored folks came in there and they wanted that, and he gave it to them...[the mob] found out and they just went in there and wrecked his place."

Ross B. Wright was eleven during the riots and recalled firefighters trying to control the mob. "Number Two Engine House...on the north side of Jefferson Street between Third and Fourth was called out. They came through with a hose in the alley" on Fifth Street "to turn the water...on the crowd to drive them away. They found they had no hose and no water. Somebody had cut the hose."

Edith Anderson Butler was a singer for the famous preacher Billy Sunday. In 1908, she and Charles Butler, who would become her husband, were singing for Sunday's revivals in Petersburg, about twenty miles northwest of Springfield. When they heard about the riots, Charles and another man from Sunday's group accompanied Edith and her sister back to Springfield. Edith's father insisted that the men stay at their house, but "Mr. Butler just laughed at Papa," according to Edith.

> *He said, "Mr. Anderson, you know I come from South Georgia, and I have seen so many riots; I want to see how you northerners pull it off." They stayed downtown…at the St. Nick* [St. Nicholas Hotel] *and followed the riot crowd all around. Saw them hang the old colored fellow* [William Donnegan] *over here on Edwards and Spring.*

Donnegan (sometimes spelled "Donigan" or "Donnigan") was an eighty-four-year-old, rheumatic black shoemaker and property owner who was married to a white woman. The mob lynched him in front of his wife and family on August 15—the second night of rioting. The next day's *Illinois*

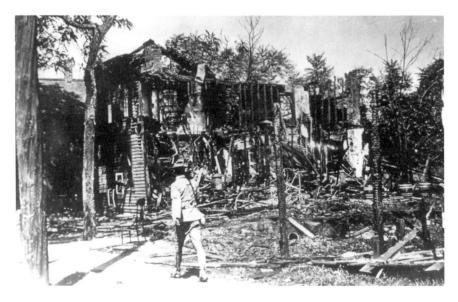

A man walks through the burned homes of some of Springfield's black residents after the 1908 race riots. *Courtesy of the Sangamon Valley Collection, Lincoln Library in Springfield, Illinois.*

State Journal said Donnegan had brought African Americans up from the South during the Civil War and found jobs for them. "This fact may have been known by some of the men in the [mob], who probably concluded that Donnigan was the cause of a great many negroes being in the city, and acted upon the supposition."

John and Hazel Wilson, who were black, were both nineteen during the riots. Hazel's family sought shelter with friends near Edwards and Spring Streets, where Donnegan was lynched, but they left when they learned the mob was headed that way.

"So we all went out to Washington Park and stayed until morning," Hazel said. "We couldn't take any belongings; couldn't take anything with you walking out to a park." They couldn't sleep either, she added. "We didn't know what to expect."

Her husband, John, said, "[The mob was] coming right down the street like, you know how a crowd comes in a parade? That's how they come, breaking windows, going in, taking what they wanted. People were up there in the area of Washington Street shooting down on you as you was coming up. They never did tell you the truth about how many people were killed."

William F. Lee, a white railroad worker who was twenty-six at the time, was fired upon there.

"The niggers used to live on the corner of Washington and Ninth Street or Tenth," he said. During the riots, the African Americans were on the roofs of buildings on Washington "with these old Springfield rifles. Well, I was standing across on the west side of Washington Street with my hand up on a telegraph pole, and *zing, zing*, and the slivers just flew above my fingers, and I left," Lee said, laughing.

"I belonged to the [Ku Klux] Klan, I don't mind telling you," continued Lee.

"Well, there was a house down on Eighth Street, a colored family lived in it, and there was about ten of us went down and knocked all of the window lights out of that house and everything else," he said.

The mob also targeted Loper's restaurant on Fifth Street, about a block south of the downtown square. It was owned by Harry Loper, who loaned the sheriff his car to take the jailed black men to Bloomington. When the mob found out, it trashed his car and business.

"I seen…one of the dry goods or clothing merchants out on the street picking bricks…and throwing them through Loper's Restaurant. And, of

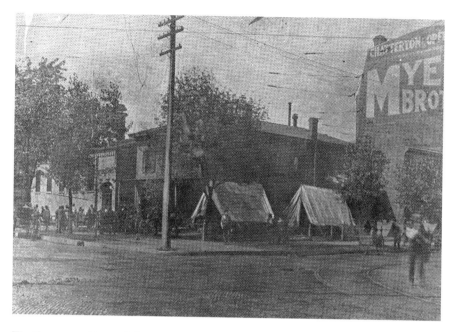

The Sangamon County Jail, at the southwest corner of Seventh and Jefferson Streets, where a mob gathered to attack two jailed African American men whom whites had accused of crimes. *Courtesy of the Sangamon Valley Collection, Lincoln Library in Springfield, Illinois.*

course, I went down into Loper's, and I and [a friend] went down and knocked the cash register over and got the change out of it," Lee said, laughing.

He continued: "Boy, I want to tell you it was pathetic. You know, there was a lot of colored people burnt up in that riot…There's guys that don't give a damn what they do or how they do or who they do it to."

Frances Chapman, a white woman, was ten during the riots and remembers it from a child's perspective. "The governor [Charles Deneen] had the militia come, and they camped on the state capitol grounds to try to keep law and order…My brother and his friend, Palmer Babcock, filled this little wagon full of pears and peaches and fruit and things that we had in the yard so they could go down and give them to the soldiers and they'd get to talk to the soldiers," she said, laughing.

Chapman's mother tried to keep her and her brother calm by "making us take a second bath," Chapman said. "Two baths in one day was just too much!" But it worked. "We raised such a riot that we didn't hear the commotion like we would have had we been out playing in the yard."

After one of the lynchings, Chapman and her friends walked to the tree where it happened. "That's how I knew they'd taken all the bark off the tree," she said. Souvenir hunters stripped the tree of bark almost immediately.

In the aftermath of the riots, 157 people were arrested, indicted or cited for the riots, according to the June 1, 2008 *State Journal-Register*. Only one was found guilty. The charge was petty theft.

A month after the riots, the white woman who helped spark them by claiming that a black man assaulted her admitted that she had lied.

PART V

SUFFERING

THE MILLERITES' DISAPPOINTMENTS

On March 21, 1843, a group of Springfieldians gathered in a grove west of downtown, waiting for Christ's Second Coming. They were Millerites, followers of a New York farmer named William Miller, who believed that he could foretell the exact day of Jesus's return through a careful interpretation of the Bible.

In the early 1820s, Miller became convinced that Jesus would return about 1842 or 1843. He believed that he had a divine obligation to tell others, so Miller began speaking around the East Coast, and his message spread through pamphlets and newspapers.

The Millerites, or "Adventist's movement" as they were also called, were one of several doomsday religious sects that developed during this period. Miller's predictions were based on challenging mathematical calculations, according to Paul Boyer, professor emeritus of history at the University of Wisconsin–Madison. (Boyer wrote a book about apocalyptic prophesies titled *When Time Shall Be No More.*)

Miller used a "complicated" and hard-to-follow system, according to Boyer. Its basis was the book of Daniel and the date of the demand to rebuild the Jewish Temple. After some "circuitous" math (calculating the square root of pi looks easy by comparison), Miller calculated that Jesus would return in 1843.

Millerites weren't on the fringe of society, they were regular Americans, according to Boyer. Some were respected leaders in other movements, such as abolitionism.

"By 1843, probably over one million people had attended the Millerites' various camp meetings, and between 50,000 and 100,000 of these were persuaded to bring their earthly affairs to an end," noted the University of Virginia's Millenialism homepage.

That included some Springfieldians who were waiting for signs of the Second Coming. Miller predicted that a seismic roar would herald it. He described the sound in a circa 1843 article titled "A Scene of the Last Day": "'AH! what means that noise? Can that be thunder?…It shakes the earth."

One day in 1842, Springfieldians heard "a strange rumble," wrote Helen Van Cleave Blankmeyer in her book *The Sangamon Country*. As it got louder and closer, local Millerites felt sure that the prophecy was coming true. But they didn't see Jesus; they saw a train—the first to come to Springfield.

They were undaunted, though. Others, however, denounced Miller and his followers. One critic was "WM Smith" from Nauvoo, where the new religious group the Mormons had recently settled. The Mormons derided Miller, and Nauvoo's papers often printed anti-Millerite items.

While visiting Springfield, Smith heard a Millerite speak on February 21, 1843, at the statehouse. He summarized the lecture in the March 1 *Nauvoo Times and Seasons*. (Springfield's paper, the *Sangamo Journal*, ignored the speech.)

Smith called the group a "strange, deluded sect" and said the Millerite speaker prayed ad nauseum. ("This prayer consisted of broken, vain, and frequent repetitions, such as—O Lord, have mercy! O Lord, give us wisdom!…the sound of amen afforded me great relief.") Smith said the speaker made a convoluted argument and referred to a complex chart to illustrate the Millerites' beliefs. Smith wrote, "Is this Millerite's chart sufficient to warn the world of its destruction?"

It was for the Springfield Millerites, who were preparing for the end. According to Blankmeyer, they "made themselves white robes such as they had seen angels in pictures wear and they gave away all their belongings."

On March 21, 1843, the day Miller predicted Jesus would return, they "met in the lovely grove which used to be where the [Howlett] building is now (at the corner of Second and Edwards Streets)," Blankmeyer added.

"They wore their angel robes—both men and women—they sang hymns and prayed and sang more hymns, but at last the sun set, just as it always had, the night came and went, too, and the world did not come to an end."

To Millerites, the day became known as "the first disappointment." They redid their calculations and realized that they were off by one year. The Second Coming was really March 21, 1844.

A year later, that day became known as "the Great Disappointment."

CAMP MISERY

During the Civil War, Springfield had one of Illinois' largest soldier training camps: Camp Butler, located about six miles northeast of Springfield and west of the present Camp Butler National Cemetery near Riverton.

The camp was established quickly but not well. According to the camp's history (written by cemetery staffer Mabel Workman), on August 2, 1861, officials announced the camp would be established, and within three days twenty-three regiments arrived. The buildings were shacks, according to the U.S. Army surgeon who inspected the camp. Dr. J.C. McKee wrote that the barracks were "mere shells, single boards forming the sides and roofs; the sides very low…the roofs covered with tarred paper…they afford protection neither from storms nor heat." (His July 1862 report is part of the fifth volume of the *Medical and Surgical History of the Civil War*.)

Camp Butler wasn't made to hold the legions of soldiers dumped at its door. Five thousand men arrived within the first few weeks. Overcrowding, poorly built barracks and central Illinois' extreme weather contributed to rampant disease and death.

The first fatality occurred just two and a half weeks after the camp had opened. A soldier died of "lung fever," according to the camp history.

Camp leaders began to assemble a medical staff, including a surgeon, hospital steward, druggist and nurses, among others. Nurses had to be "plain women over the age of 30," the camp history noted. "Hoops were to be abolished and nurses were to be made walking spindles" in regulation uniform, which was a brown dress, pantalets "tight around the ankles" and a black hat.

Six months after it opened, Camp Butler was also designated as a prison camp. After the Union victory at Fort Donelson, Tennessee, in February

1862, about 2,500 Confederate prisoners of war were shipped here. The camp established separate hospitals for Confederate and Union soldiers. Prisoners started dying almost immediately. Anyone terminally ill was sent to the "death house."

More patients meant more supplies. On March 1, Camp Surgeon Dr. Thomas Madison Reece sent the Medical Purveyor's Office in Chicago a request for nearly every type of medicine available to hospitals. (The request is among his papers at the Abraham Lincoln Presidential Library.)

Among many things, he asked for ether (an anesthetic), 192 bottles of alcohol (a stimulant, general tonic and mixer for other medicines), belladonna extract (for intestinal cramps), sulfate of magnesium (a laxative), blue mass pills (potentially toxic mercury-based pills for diarrhea or constipation), opium (for diarrhea or pain) and potassium iodide (for syphilis or cleaning wounds).

"The sickness among the prisoners has almost assumed the features of an epidemic," noted the March 10, 1862 Springfield paper, the *Illinois State Register*. "We learn that on the afternoon of Friday, no less than 9 deaths occurred, and in the previous days the daily average of mortality was 3 or 4." Days later, 15 men died on a Saturday, the paper said.

Fatalities were such a problem that the camp's director ordered a camp carpenter to construct coffins to save money, according to Lonnie R. Speer's *Portals to Hell: The Military Prisons of the Civil War.*

Dr. McKee, the surgeon who checked Camp Butler for the U.S. Army, arrived here on May 1, 1862, and said the stench was "horrid," the medicine supply was lacking and typhoid, pneumonia and erysipelas "raged."

The camp's six hospitals were "in a miserable sanitary condition," he wrote. "The floors were filthy; deodorizing agents were not thought of; slops and filth were thrown indiscriminately around. The sick were crowded in wooden bunks; some on the floor, many without blankets." McKee initiated a camp cleanup that, he said, resulted in far fewer fatalities the following month.

Within a month and a half, 336 soldiers and prisoners were hospitalized, the largest number during Camp Surgeon Reece's tenure, according to his records. Naturally, he needed more medicine. So he sent another request to the Purveyor's Office.

This time, however, ugly government bureaucracy intervened (these letters are part of Reece's papers at the ALPL). On July 30, the office refused

Reece's request, saying his letter "should have been in duplicate." His order would not be filled until he resent it properly.

How many soldiers died as a result of some detail-obsessed, heartless bureaucrat? We'll never know.

Two years later, Camp Butler was still overcrowded and disease-ridden, according to a February 1, 1864 letter by regimental lieutenant George R. Clark. He was asking officials to build additions for the hospitals, which were bursting at the beams.

Unfortunately, we don't know the rest of the story. An 1865 fire burned down the hospital office building and destroyed records.

The camp served as a training camp and mustering-out facility until the end of the war. It closed on June 19, 1866.

There are 714 Union soldiers and 866 Confederates buried at Camp Butler National Cemetery.

SPRINGFIELD SUFFERS THE SUFFRAGISTS

At a time when slaves had been free only a few years, some Americans were calling for women's freedom. They believed women should be able to vote and participate in the traditional men's worlds of business and politics. Many thought they were ridiculous, much like the early abolitionists who called for slaves' freedom.

Some of those suffragists, including one of its stars, presented their case to Springfield—and got a lukewarm reception.

On February 20, 1869, three months before she and Susan B. Anthony formed the controversial National Woman Suffrage Association, Elizabeth Cady Stanton came here to argue for women's right to vote. She and Anthony are now considered two of the founding mothers of the women's rights movement.

Stanton was accompanied by Mrs. D.P. Livermore, a Chicago suffragist. The *Illinois State Journal* theorized that Stanton came to town to encourage legislators to approve women's rights legislation.

Fat chance, it added.

"We are inclined to think that these ladies will have some difficulty in convincing our legislators, or indeed a very large portion of our community,

that woman suffrage is any such panacea for the ills of bad legislation and bad officials," it noted.

The editorial quoted a Reverend Collier, who had debated with Stanton and Livermore in Chicago. "I may stand the drudgery that a republican form of government imposes upon me, but a woman cannot." Collier wished women would "perform the duties that lie immediately at their feet" instead of "clamoring for more rights."

"I believe that history will endorse this statement," he continued, "and I believe furthermore, that the prostration of [women's] feminality [sic], the bringing down from this high pedestal of her higher and purer nature and mixing into these necessary duties of a republican form of government will soon make her deeper in intrigue, more unfeminine, and, therefore, the corrupter in government." The Chicago audience reacted with "hisses, disorder and applause," the paper noted.

"We cannot think," the editorial added, "except with disgust, of pure, chaste and refined women coming to political gatherings and placing themselves on a level with the indiscriminate and rude crowds who meet and mingle at such places…Instead of being 'purified and exalted,' they would be soiled and degraded."

You'd think they were talking about mud wrestling.

Stanton and Livermore spoke at Springfield's opera house, then located at Sixth and Jefferson Streets, to "a crowded and fashionable audience, a large part being ladies…several of the State officers, a number of leading members of the Legislature and a plentiful sprinkling of noted politicians and lawyers," according to the February 20, 1869 *Illinois State Journal*.

Illinois lieutenant governor John Dougherty and Cook County judge James Bradwell spoke and argued for suffrage as well. Bradwell explained how Illinois' laws "utterly failed to protect" the rights of married women. He said he expected state legislators to approve a law that would "give women exclusive control over their own earnings" and "perfect" the law of marriage "in relation to the control of children and property." (It wasn't until later that year, 1869, that Illinois law allowed women to keep any money they earned while married; previously it became their husband's property, according to Jane M. Friedman's *America's First Woman Lawyer: The Biography of Myra Bradwell*. Worse yet, Friedman wrote that it took two more years until Illinois law gave mothers custody rights to their own children. Prior to that, the

children automatically went to whomever the father chose in the case of the father's death or abandonment.)

Livermore argued for women's rights to "education in our highest schools, to enter the professions and partnerships, to have an open field to labor with man...with like pay, and full and equal rights under the laws," according to the *Journal*.

Stanton spoke last, for nearly an hour, and explained how she became involved with the movement nearly twenty years before. "Most of her arguments are familiar to the public," the paper said, "though she illustrated many of the questions with apt and forcible anecdotes and pathetic passages."

At the end of her speech, the paper noted, "Mrs. Stanton requested that anyone in the audience who desired to have any doubt satisfied question her, but no one responded...She then moved that all who favored woman suffrage should stand up; but as few seemed disposed to rise, she altered the motion that all who favored should retain their seats, which was unanimously done."

Sadly, neither Stanton nor Susan B. Anthony lived to see their dream realized. Stanton died in 1902 and Anthony died four years later.

Women didn't have the right to vote until August 26, 1920, when the Nineteenth Amendment became law.

COMING TO THE LAND OF LINCOLN

Nearly half of all Americans have a tie to Ellis Island, according to the Statue of Liberty–Ellis Island Foundation website. Half of us have an ancestor who was processed at Ellis Island, a small island off Manhattan that was America's doorway for twelve million immigrants from 1892 to 1954.

Some of those immigrants came to Springfield. Their stories reflect the hopes, dreams and despair of people who came here for many reasons: to find a job, spouse or freedom or to join family, for example.

Among them was a former Springfieldian, Reverend Michael Maietta, and his family. Maietta was four and a half years old when he emigrated in 1902 from Avella, Italy. He recorded his memories in a 1972 oral history for the University of Illinois–Springfield. (Maietta died in 1974.)

His father had been working as a laborer in America since 1900, earning money to bring his wife and children here. His father emigrated to get a

job because "things were pretty well at a standstill in the area where he was from," Maietta said.

All his dad could afford for the family were tickets for steerage, the lowest class of passengers. "The majority of the persons in that lower compartment were Italians," Maietta said.

Steerage was no picnic. The travelers were often packed together and had bad food, little privacy or fresh air, according to *On the Trail of the Immigrant* by Edward A. Steiner.

Even though he was young, Maietta remembered the trip. They were confined to their bunks, perhaps due to the weather. "Ordinarily, there'd be just normal conversation and maybe some excited words that perhaps people wouldn't ordinarily use, but during those stormy days and nights there was a lot of praying going on," Maietta said. His family settled in Connecticut, where they knew others, but he eventually came to Springfield, was ordained and worked at the Washington Street Mission.

Another immigrant, Nick Campo, came here in 1912 to find a job. He had traveled from Montevago, Italy, where he was born in 1894. He had a brother in Springfield and another in Farmersville who were coal miners. (Campo recorded his memories for a UIS oral history in 1974; he died in 1982.)

"I had a very bad trip," he said. "I caught bad cold, and my eyes were watering so bad, they were sticking…I couldn't hardly see, I had to wash my eyes every few minutes." Campo was probably in steerage, too, as he described being in a room with four bunks.

He was seasick the whole fourteen-day trip.

"The food wasn't very good, and they weren't too clean [on the ship]," he said. "The water wasn't fresh water…it was just seawater and it was greasy. You wash your utensils, your dishes and everything else [in it]…Bad, very bad."

There were more worries at Ellis Island.

We were in a big room, must have been 750 to 800 people, all of us sitting there, waiting. And they gave us a little box; it cost us one dollar. They had a couple of bananas and four or five sandwiches and this and that to take for the trip [to their destination in the United States].

So pretty soon, somebody calls my name, and they took me in a room. There was three of us. And they call some woman that had left her husband without her husband's consent and they says, "You've got to go back."

Suffering

Pretty soon, they called this man and they said that the law wanted him over in Sicily—he had to go back. And I thought to myself, "Well, I'm going back." And I figured, "If I'm going to have to do that… I'll jump overboard and drown myself." That's how discouraged I was.

Instead, Campo was asked a few questions and sent on his way.

He had left Italy on April 10, 1912. Five days later, the *Titanic* sank en route to America. That changed some immigrants' minds about traveling here, and it improved the safety of those who did.

Braver souls like former Springfieldian Mary Scott Sampson still came, but their trips were affected by the disaster.

Sampson was born in Scotland in 1892 and immigrated to Springfield in 1923. She described her trip in a 1975 interview for the University of Illinois–Springfield's Oral History Archives.

Sampson came here to marry her boyfriend, who had asked her to immigrate a year earlier. She was reluctant to leave home but reconsidered when a friend told her America was starting an immigrant "quota system" that might greatly delay her travel.

According to the Ellis Island website, in the early 1920s, lawmakers passed quota laws that restricted the number of immigrants from each country. This was done to "preserve the ethnic flavor of the 'old immigrants'…The perception existed that the newly arriving immigrants, mostly from southern and eastern Europe, were somehow inferior to those who arrived earlier," the website notes.

Many immigrants rushed to beat the quotas. As a result, Sampson and others' trips were postponed at least once. She finally left Scotland in September 1923 as a second-class passenger.

Her voyage was better than third class (steerage), where passengers were packed like cattle in the ship's bottom, but it wasn't as cushy as first class. "You never go to first class unless you are a passenger," she said. "But second class could go down to steerage," which she did to visit friends.

Unlike steerage, second class had daily entertainment. "The ship would have its own orchestra, but they usually played for the first-class passengers. They would eventually come to second class at a certain time," she said.

The class segregation had been the same on the *Titanic*, but that ship's sinking had improved some things. Sampson's ship, and all others, were required to have sufficient lifeboats and safety drills.

"If you didn't show up [for the drill], they would come look for you," Sampson said.

"I wouldn't have cared if [the ship] had gone down," she added, describing her violent seasickness. "Just heave, heave, heave and heave." Some immigrants lost twenty to thirty pounds. Sampson lost plenty, and a stewardess encouraged her to eat, saying, "You look so pale and so thin; they never will let you off [the boat] when you get to New York."

Only sickly first- and second-class passengers had to be inspected at Ellis Island before being allowed in the country; the rest were quickly inspected in the comfort of their ship. However, all steerage passengers had to undergo physical, mental and legal exams at Ellis Island. The government wanted to ensure that immigrants wouldn't become dependent on the state for medical or other reasons, so "six second physicals" and other tests determined which unfit immigrants would be sent back home.

"By 1916, it was said that a doctor could identify numerous medical conditions (ranging from anemia to goiters to varicose veins) just by glancing at an immigrant," according to the Ellis Island website.

As immigration exploded, the United States passed laws further restricting who could enter. By the time Sampson immigrated, the list was long, according to *Ellis Island Interviews* by Peter Morton Coan. It included "all mentally disabled persons, paupers…those suffering from a 'loathsome or contagious disease,' those convicted of a felony, an egregious crime or a misdemeanor involving 'moral turpitude,' anarchists, and illiterates."

Despite her sickness, Sampson did "get off the boat" and headed straight for Springfield, where she got married the day after she arrived.

Former Springfieldian Ann Montalbano and her mother weren't as lucky when they emigrated from Italy in 1921. They were joining Ann's father, whom she had never met. She was ten and a half years old, and her father had worked here her whole life.

When their ship landed in New York on February 14, 1921, it was quarantined. Montalbano, who died in 1993, described the experience in her 1974 UIS Oral History: "At that time they were lots of ships coming in from all parts of the world and on account of sickness, lice and so forth, all the ships were quarantined and had to wait…to disembark their patrons."

Suffering

Her father, Leo Malone, had traveled from Springfield to meet them. He could only wave at them from the dock. Montalbano asked her mother which man was her father. "It's the man with the green felt hat," she replied.

He came every day while the ship was quarantined. In order to communicate on the noisy dock, Montalbano's mother threw her husband a rope from the ship. He attached a basket and a note, which Montalbano read for her illiterate mother. Montalbano wrote to her father that she was cold and needed a coat. "He used to bring food that the relatives [in Brooklyn] prepared...boiled eggs, bananas, fruit, chicken soup" and put it in the basket, she said. "And we'd pull it up."

After fourteen days of quarantine, Montalbano and the other passengers were allowed to disembark, and Montalbano hugged her father for the first time in her life.

MISCELLANY: FROM BASEBALL TO UFOS

TOWN BALL HITS HOME

About the time of the Civil War, baseball fever struck Springfield. Like golf, it was brought here by residents who saw the game played in the East, and its popularity spread fast.

Lifelong Springfield resident John C. Cook wrote about the town's early baseball in the *Illinois State Journal* on March 20, 1927, when he was seventy-two. "Prior to the advent of the great national game of baseball, there was known the game of 'town ball,' that had no organization, but was played by the youth promiscuously," he wrote.

> *The ball was generally of solid rubber or cork, with a lead bullet in the center, and wound about with woolen yarn and covered with some kind of leather, usually a piece of buckskin. The bat was usually a piece of pine fencing with a handle and of two or three foot length.*
>
> *The batter, after hitting the ball, ran for the base, and in order to be "put out" was either "soaked out" by being hit with the ball by the fielder or "crossed out" by having the thrown ball pass between the batter and the base.*

Town ball was an offshoot of the English game "rounders," according to John P. Rossi's book *The National Game*. He said that the number of players

and bases varied and that the rules changed according to whether the game was played in the city or country.

In Springfield, and throughout the country, town ball and its variations gave way to baseball, locally referred to in the 1860s as "base ball."

"Some citizens had been east during the spring of the year," Cook wrote in the *Journal*, without specifying which year, "and had seen the start of the new game and brought a brief knowledge of it to the town and, if I am not mistaken, brought home a ball and bat for the children. The ground was marked off for the bases and the top of an old 'wash boiler' used as one of them."

Soon after, baseball "clubs" were organized, Cook wrote. Some of Springfield's earliest were the Capitals, Olympics, Mystics and Stars. Their games and club meetings were announced in the *Illinois State Register* in the summer of 1866. By the mid-1870s, "match games" were held with teams from Quincy, Peoria, Bloomington and Chatham.

Games were arranged when one team "challenged" another, and these challenges were announced in the local paper, too. "Competition between clubs during these years was quite formal," wrote Warren Jay Goldstein in his book *Playing for Keeps: A History of Early Baseball*. "In order to arrange a

These men formed one of the town's early baseball teams. *Courtesy of the Sangamon Valley Collection, Lincoln Library in Springfield, Illinois.*

match, a club first issued a written challenge to the club it wished to play: the challenged club then decided whether to accept the challenge."

At the game's end, the losers presented some kind of trophy to the winners, and both sides gave a short speech, according to Goldstein. Then the partying began. The host team typically fêted the players at a local tavern, sometimes well into the night.

"The usual trophy for match games was…a rosewood or mahogany ball bat, mounted with silver handsomely engraved and the wood highly polished," John Cook wrote in the *Journal*.

"In the early stages of baseball there were no gloves worn, no spiked shoes, though each club was uniformed in bright colors, mostly red and blue," Cook said. "There were no regular dimensions for bats, but almost everyone owned his own and had it 'turned' at the mill to suit his fancy." In addition, "The catcher stood almost as far behind the batter as the pitcher stood in front."

Match games with out-of-town teams were big events, according to Cook.

> *The society people turned out in force and the DuBois orchard* [in the general area of the present Sacred Heart-Griffin High School] *was well filled with buggies and carriages, occupied by the fair damsels of Springfield, all of whom were gaily attired, with beautiful hats and bright parasols, and some of them had beaux on the team, whose dexterity was much enhanced by their presence.*

By September 1875, some of those damsels had hit the field.

"Ever since the organization of the Female Base Ball Club there has been considerable curiosity to see how the 'Blondes' and 'Brunettes' deported themselves upon the diamond field, and accordingly the exhibition game on Saturday was witnessed by quite a large crowd," said the September 13, 1875 *Illinois State Journal*.

"It was evident that both sides were 'rattled'…and in the earlier innings displayed little playing," the article noted, but they improved as the game went on and did as well as their few practices allowed.

The paper noted the women's uniforms were decorous and that the field had been modified for them to "a trifle over half that of the ordinary field."

"It should be added," the paper reported, "that no immodest act—save female base ball playing be so considered—obtruded itself, nor was [*sic*] there other objectionable features. The players conducted themselves like regular ball players—as much so as females can."

And the "Blondes" won. Big surprise.

Hot Air Over Illinois

Seven years before the Wright brothers' first flight, Illinoisans and other Americans were boggled by strange objects in the sky. The name "unidentified flying object" hadn't been invented, so observers called them "airships."

The "great airship wave of 1896–97," which has spawned books and contemporary UFO studies, began in November 1896 when an airship with a bright light was seen in Sacramento, California, says Thomas "Eddie" Bullard, PhD, a folklorist and UFO author from Indiana who researched the phenomenon extensively.

"The story went out that someone had invented a successful flying machine, and reports of this airship, or at least its supposed headlight, spread up and down California and…into Nevada," he says. Sightings continued westward until they hit Illinois in April. Illinois reported the most sightings of any state, according to Bullard.

From Cairo to Chicago, newspapers described people seeing "a gigantic aerial boat" or an "airship" with colored lights.

"Airships in the sky appear to be all the rage" noted Springfield's April 12, 1897 *Illinois State Journal*.

"Monday night the mysterious airship which has been seen in Nebraska, Iowa, Illinois and Wisconsin, paid a visit to Lincoln [Illinois]," reported the April 13, 1897 *Lincoln Daily Courier*. Fifty people standing on Pulaski Street saw the "rapidly moving, V-shaped" ship. "It came toward Lincoln with a headlight as large as an arc electric lamp."

Two days later, "hundreds" of Springfielders and some state legislators saw it, too.

"A number of persons standing on the corner of Fifth and Monroe streets about 7:30 o'clock last evening saw a large, brilliant light in the heavens. The light was moving rapidly and was at a great height," reported the

April 16 *Illinois State Register*. Some observers climbed to the "roof garden" of the Odd Fellows' Building (one of Springfield's tallest buildings at that time, located at the southeast corner of Fourth and Monroe Streets) to get a better look.

The day before, residents Adolph Winkle and John Hulle (spellings varied) had reported that they saw the airship land and even talked to its passengers. "Of course, no one believed the story," retorted the April 16 *Register*.

The Decatur paper might have taken them seriously, though. Its April 16 *Daily Republican* noted:

> *Farmhand John Halley and local vineyard owner Adolf Wenke said that it landed three miles west of the city along the Jefferson street road. They said a long bearded man emerged and inquired where he was. Inside the car was seated another man and also the scientist's wife. He said they usually rested during the daytime in remote parts of the country in order to conceal the vessel's huge wings. When they asked the scientist his name, he smiled and pointed to the letter M, which was painted on the side of the car. After bidding the farmers farewell, he pressed a button and the ship flew off.*

Sightings died out the next month.

Theories about them varied: drunken observers, hoaxes, planets or stars mistaken as a ship and Martians. However, many people hoped they were proof that Americans had finally invented a flying machine.

In *Solving the 1897 Airship Mystery*, author Michael Busby wrote that the airships were real and were funded by magnate George Hearst (William Randolph Hearst's father) to get the United States entangled in the war with Cuba.

Bullard says the sightings were "hot air":

> *There are no genuine UFOs among the 1897 airships…Many honest and reliable people reported a light in the sky, but their description of how the light sank slowly toward the horizon makes it clear they were looking at Venus or another heavenly body. Other honest people reported a structured object with lights, moving in a manner and direction no heavenly body could manage, but these people were the victims of a hoax. What they saw was a fire [hot air] balloon…a form of Fourth of July "firework" available*

in drug stores year 'round. A follow-up of sightings…often revealed the
jokesters or reported the burnt-out carcass of the balloon had landed in some
farmer's field, now and then starting a fire.

The remaining sightings were lies, Bullard says, concocted by locals or the
press for entertainment and sales.

DID POLITICS SAVE NEW SALEM?

If not for media mogul William Randolph Hearst, the Lincoln's New Salem
State Historic Site might still be a cow pasture.

In 1906, Hearst was a wealthy New York congressman who owned several
newspapers and had hopes of becoming president. On August 17, he stopped
here while traveling back to New York from his childhood home of San Francisco,
where he had been helping victims of that April's catastrophic earthquake,
according to Ben Procter's *William Randolph Hearst: The Early Years, 1863–1910.*

Officially, he came here to speak at Petersburg's Old Salem Chautauqua, a
summer festival of speakers and entertainers that drew 100,000 visitors at its
peak and was located across the river from Abraham Lincoln's former village,
according to *A Chautauqua to Remember: The Story of Old Salem* by Katharine
Aird Miller and Raymond H. Montgomery. Hearst talked about "Political
Independence," according to the August 18, 1906 *Illinois State Register.* (That
was the only Chautauqua Hearst ever addressed, Montgomery says.)

While here, Hearst surprised his audience by buying the land where New
Salem once stood and giving it to the Chautauqua's leaders for preservation.
New Salem, the pioneer village where Lincoln lived from 1831 to 1837, had
become livestock fodder by then, according to Miller and Montgomery's
book. "Salem Hill," as it was called, was "a cow and hog pasture, in which
the only semblance of what it had once been were the depressions marking
where the cellars and buildings once stood."

Why would a wealthy congressman buy a cow pasture in the middle
of nowhere?

Montgomery has a theory. He and his co-author researched documents
and interviewed area residents who lived during that time. First, he says,
Hearst was a philanthropist who helped many groups. Second, he could

An image of the "Ruins of Salem Hotel" at New Salem from the *Illustrated Atlas Map of Menard County, Illinois, 1874. Courtesy of the Sangamon Valley Collection, Lincoln Library in Springfield, Illinois.*

afford the $11,000 or $12,000 (accounts vary) price tag for New Salem's land. Most importantly, Montgomery believes, it would have helped Hearst's presidential aspirations.

Before Hearst bought it, the land was owned by Petersburg's Bale family, who were being pressured by "a group from Springfield" to sell it, Montgomery says. "The story that's told, and I'm not sure it's absolutely correct, is the Bale family supposedly didn't want this to be turned over to a group to make a beer garden out of it." They wanted it to become a Lincoln memorial. So they sought help from the Chautauqua leaders, among whom were influential people, according to Montgomery.

Some of those leaders met with the powerful central Illinois congressman Henry T. Rainey, from Carrollton, in 1905. (Rainey was a Chautauqua supporter and spoke at the festival that summer.) Montgomery thinks that the group asked him for help in preserving the pioneer village site, and he then approached Hearst about buying the land. Doing so could have helped Hearst get Rainey's support in Congress and for a presidential bid, plus it would have won the hearts of Illinoisans, which could only help a national campaign.

When Hearst arrived in Petersburg that hot August morning in 1906, Chautauqua leaders met him at the railroad station and immediately took him to Salem Hill, according to Montgomery and Miller's book.

After Hearst spoke at the Chautauqua that afternoon, Rainey announced Hearst's gift of the New Salem land to the Chautauqua association. The eight-thousand-member audience responded with "tumultuous applause," according to the August 18, 1906 *Illinois State Register*, which predicted that Chautauqua would establish its summer schools there and build a ferry across the adjacent Sangamon River, as well as a bridge named after Hearst.

Instead, the land sat fallow for about ten years, even though Hearst stipulated in the deed that the land would become his if the Chautauqua association did not use it as he wished.

"In 1917, the Old Salem Lincoln League was formed at Petersburg, to carry on research work [on the pioneer village site] and keep alive the interest already aroused," noted 1934 state records about New Salem's restoration. "The Chautauqua association, with Mr. Hearst's consent, conveyed the site to the State of Illinois to be used as a State Park, and in 1918 the League, with funds raised by popular subscription, erected several cabins on original sites, built a road, marked other cabin sites and in celebration of the occasion, gave a pageant depicting scenes of pioneer days."

When Hearst approved the Chautauqua association's proposal to give the land to the state for a park, he "indicated he wanted the park to be forever free," Montgomery says.

ODE TO A LEGISLATIVE HUSBAND

It must be tough to be a lawmaker's spouse. Your better half is in Springfield days on end during the long legislative sessions. At least most lawmakers can travel back home on weekends now. It was worse in the 1800s, when they often stayed here for months while the legislature was meeting. The lack of quick transportation made going home impractical.

Could a long winter and spring alone have driven one rankled legislative "widow" to wax poetic?

One book local historians often refer to is the extremely comprehensive *History of Sangamon County, Illinois*. It's a serious book that covers many topics about our area's past.

However, a short entry titled "Our Legislators" on page 558 seems to be more tongue-in-cheek. It reprints a poem that it states was written by a

rural legislator's wife who thought session was taking too long and needed her husband back home on the farm. The poem was a parody of a popular temperance song from the time that went "Father, dear father, come home to me now."

Here are a few stanzas:

Husband, dear husband, come home to me now,
From the city and State House so warm,
'Tis lonely without you, why do you not come
And see to the things on the farm?
You told me when you were elected last fall,
If I would but once let you go,
You'd surely return before April was past,
And I really believed 'twould be so.
Come home! Come home! Come home!
Dear husband, kind husband, come home...

Husband, dear husband, come home to me now,
The garden needs spading for peas,
The boys should be picking up stones in the lot,
And you should be trimming the trees.
When will you get through with bills and resolves,
Stop talking of license and rum,
Of railroads and tunnels, and other such things,
And tend to your business at home?

Husband, dear husband, don't write to me more
Of the theater, lobby and club,
Nor dinners you have eaten at Parker's and Young's
But hurry away from the hub.
Yes, hurry back home, your Betsy is sad,
Her heart so honest and true;
All winter she's slept in the bed-room alone,
And say, dear husband, have you?...

BIBLIOGRAPHY

BOOKS AND BOOKLETS

Angle, Paul. *Here I Have Lived: A History of Lincoln's Springfield.* Chicago, IL: Abraham Lincoln Book Shop, 1971.

Baker, Jean H. *Mary Todd Lincoln: A Biography.* New York: W.W. Norton & Company, 1989.

Boyer, Paul. *When Time Shall Be No More.* Cambridge, MA: Belknap Press of Harvard University Press, 1992.

Brady, David. *Hero or Hellion? The Life and Times of Robert Pulliam, Patriarch of Sangamon County.* Springfield, IL: Sangamon County Historical Society, 2005.

Bunn, George W., Jr. *The Old Chatterton: A Brief History of a Famous Old Opera House.* Springfield, IL: Sangamon County Historical Society, 1974.

Busby, Michael. *Solving the 1897 Airship Mystery.* Gretna, LA: Pelican Publishing Company, 2004.

Clark, William Lloyd. *Hell at Midnight in Springfield: or a Burning History of the Sin and Shame of the Capital City of Illinois.* Milan, Illinois: self-published, 1910.

Cooley, Verna. *Illinois and the Underground Railroad to Canada.* Vol. 23. Transactions of the Illinois State Historical Society. Springfield, IL: Illinois State Historical Society, 1917.

Craughwell, Thomas J. *Stealing Lincoln's Body.* Cambridge, MA: Belknap Press of Harvard University Press, 2007.

DeRamus, Betty. *Forbidden Fruit: Love Stories from the Underground Railroad*. New York: Atria, 2005.

Eames, Charles. *Historic Morgan and Classic Jacksonville*. Jacksonville, IL: Daily Journal Steam Job Printing Office, 1885.

Friedman, Jane M. *America's First Woman Lawyer: The Biography of Myra Bradwell*. Buffalo, NY: Prometheus Books, 1993.

Goldstein, Warren Jay. *Playing for Keeps: A History of Early Baseball*. Ithaca, NY: Cornell University Press, 1991.

Hart, Richard. *Lincoln's Springfield: The Underground Railroad*. Springfield, IL: Sangamon County Historical Society, 2006.

Henneke, Ben Graf. *Laura Keene: A Biography*. Tulsa, OK: Council Oak Books, 1990.

Hickey, James T. *The Collected Writings of James T. Hickey*. Springfield: Illinois State Historical Society, 1990.

History of Sangamon County, Illinois. Chicago, IL: Inter-State Publishing Company, 1881.

Jefferson, Joseph, III. *The Autobiography of Joseph Jefferson*. New York: Century Company, 1889.

Karch, Steven. *A Brief History of Cocaine*. Boca Raton, FL: CRC Press, 1998.

Krupka, Francis Orlando. *Historic Structure Report: Abraham Lincoln Home*. Lincoln Home National Historic Site, Springfield, Illinois. Washington, D.C.: National Park Service, 1992.

Kunhardt, Dorothy Meserve, and Philip B. Kunhardt Jr. *Twenty Days*. New York: Harper and Row, 1965.

Masters, Edgar Lee. *Vachel Lindsay: A Poet in America*. New York: Charles Scribners Sons, 1935.

McWorter Simpson, Helen. *Makers of History*. Evansville, IN: Laddie B. Warren, 1981.

Merritt, Carole. *Something So Horrible: The Springfield Race Riot of 1908*. Springfield, IL: Abraham Lincoln Presidential Library Foundation, 2008.

Miller, Katharine Aird, and Raymond H. Montgomery. *A Chautauqua to Remember: The Story of Old Salem*. Petersburg, IL: Silent River Press, 1987.

Neely, Mark E., Jr. *The Abraham Lincoln Encyclopedia*. New York: McGraw-Hill, Inc., 1982.

Neely, Mark E., Jr., and R. Gerald McMurtry. *The Insanity File*. Carbondale: Southern Illinois University Press, 1986.

Oldroyd, Osborn. *The Lincoln Memorial: Album-Immortelles*. New York: G.W. Carleton and Publishers, 1882.

Pratt, Harry E. *The Personal Finances of Abraham Lincoln*. Springfield, IL: Abraham Lincoln Association, 1943.

Procter, Ben. *William Randolph Hearst: The Early Years, 1863–1910*. New York: Oxford University Press, 2007.

Robertson, James I., Jr., ed. *Medical and Surgical History of the Civil War*. Vol. 5. Wilmington, NC: Broadfoot Publishing Company, originally printed 1870–88, reprinted 1990–92.

Rossi, John P. *The National Game*. Chicago, IL: Ivan R. Dee, 2000.

Ruggles, Eleanor. *The West-Going Heart*. New York: Norton, 1959.

Russo, Edward J., Melinda Garvert and Curtis Mann. *Illinois State Fair: A 150 Year History*. St. Louis, MO: G. Bradley Publishing, 2002.

Saunders, Delores. *Illinois Liberty Lines: The History of the Underground Railroad*. N.p.: Farmington Shopper, 1982.

Senechal, Roberta. *The Sociogenesis of a Race Riot*. Urbana: University of Illinois Press, 1990.

Shenk, Joshua Wolf. *Lincoln's Melancholy*. Boston: Houghton Mifflin Company, 2005.

Siebert, Wilbur. *The Underground Railroad from Slavery to Freedom*. New York: Macmillan Company, 1898.

Speer, Lonnie R. *Portals to Hell: The Military Prisons of the Civil War*. Mechanicsburg, PA: Stackpole Books, 1997.

Steiner, Edward A. *On the Trail of the Immigrant*. New York: Fleming H. Revell Company, 1906.

Still, William and Edmund Birckhead Bensell. *The Underground Rail Road*. Philadelphia, PA, 1872.

Temple, Sunderine Wilson, and Wayne C. Temple. *Abraham Lincoln and Illinois' Fifth Capitol*. Mahomet, IL: Mayhaven Publishing, 2006.

———. *Illinois' Fifth Capitol*. Springfield, IL: Phillips Brothers Printers, 1988.

Temple, Wayne. *By Square & Compass: Saga of the Lincoln Home*. Mahomet, IL: Mayhaven Publishing, 2002.

Tilley Turner, Glennette. *The Underground Railroad in Illinois*. Glen Ellyn, IL: Newman Educational Publishing, 2001.

Van Cleave Blankmeyer, Helen. *The Sangamon Country*. Springfield, IL: Sangamon County Historical Society, 1965.

Washington, John E. *They Knew Lincoln*. New York: E.P. Dutton & Company, Inc., 1942.

Weston, Mildred. *Vachel Lindsay: Poet in Exile*. Fairfield, WS: Ye Galleon Press, 1987.

MANUSCRIPTS AND DOCUMENTS

Anderson Butler, Edith. Oral history interview, University of Illinois–Springfield, Springfield, Illinois.

Atwood, Elbridge. Letter, May 7, 1865. Abraham Lincoln Presidential Library manuscript collection, Springfield, Illinois.

Bratt DuBarry, Helen A. Letter, April 16, 1865. Abraham Lincoln Presidential Library manuscript collection, Springfield, Illinois.

Brown, LeRoy. Oral history interview, University of Illinois–Springfield, Springfield, Illinois.

Campo, Nick. Oral history interview, University of Illinois–Springfield, Springfield, Illinois.

Chapman, Frances. Oral history interview, University of Illinois–Springfield, Springfield, Illinois.

Cohn, Nathan. Oral history interview, University of Illinois–Springfield, Springfield, Illinois.

Corneau & Diller drugstore ledger. Abraham Lincoln Presidential Library manuscript collection, Springfield, Illinois.

Davis, John. Memoir of Thomas Madison Davis. "Slavery – Illinois" vertical file, Sangamon Valley Collection, Lincoln Library, Springfield, Illinois.

Francis Lenn Taylor Birth Certificate, December 28, 1897. Sangamon County, Illinois courthouse records. Sangamon Valley Collection, Lincoln Library, Springfield, Illinois.

Frank M. Taylor and Elizabeth M. Rosemond Illinois Marriage Record #14236, February 27, 1890. Sangamon Valley Collection, Lincoln Library, Springfield, Illinois.

Lee, William F. Oral history interview, University of Illinois–Springfield, Springfield, Illinois.

Maietta, Reverend Michael. Oral history interview, University of Illinois–Springfield, Springfield, Illinois.

Montalbano, Ann. Oral history interview, University of Illinois–Springfield, Springfield, Illinois.

Rague, Eliza and John. Divorce papers, 1853. Illinois Regional Archives Database, University of Illinois at Springfield, Springfield, Illinois.

Scott Sampson, Mary. Oral history interview, University of Illinois–Springfield, Springfield, Illinois.

Sleeper, Sarah. Letter, June 16, 1865. Abraham Lincoln Presidential Library manuscript collection, Springfield, Illinois.

Springfield City Council Minutes, July 23, 1839. Sangamon Valley Collection, Lincoln Library, Springfield, Illinois.

Springfield City Directory, 1889–90. Sangamon Valley Collection, Lincoln Library, Springfield, Illinois.

Thomas Madison Reece Papers, 1857–1876. Abraham Lincoln Presidential Library manuscript collection, Springfield, Illinois.

U.S. Census. Christian County, Illinois, 1880. Located on www.ancestry.com.

Wilson, John, and Hazel Wilson. Oral history interview, University of Illinois–Springfield, Springfield, Illinois.

Workman, Mabel. "Camp Butler History." Camp Butler National Cemetery, Springfield, Illinois.

Wright, Ross B. Oral history interview, University of Illinois–Springfield, Springfield, Illinois.

NEWSPAPERS

Chicago (IL) Tribune

Decatur (IL) Daily Republican

Jacksonville (IL) Daily Journal

Lincoln (IL) Daily Courier

Nauvoo (IL) Times and Seasons

Springfield Illinois State Journal

Springfield Illinois State Register

Springfield (IL) News-Record

Springfield (IL) Sangamo Journal

PERIODICALS

Custer, Milo. "Asiatic Cholera in Central Illinois." *Journal of the Illinois State Historical Society* (April 1930).

Harper's Weekly. November 21, 1863.

Hart, Richard. "Springfield's African Americans as a Part of the Lincoln Community." *Journal of the Abraham Lincoln Association* (Winter 1999).

Hirschhorn, Norbert, Robert G. Feldman and Ian A. Greaves. "Abraham Lincoln's Blue Pills: Did Our 16th President Suffer from Mercury Poisoning?" *Perspective in Biology and Medicine* (Summer 2001).

Hotel Monthly (June 1912). "The 1911 Lincoln Banquet at Springfield."

Illinois State Historical Society Journal 43.

McArthur, Benjamin. "Joseph Jefferson's Lincoln: Vindication of an Autobiographical Legend." *Journal of the Illinois State Historical Society* (Summer 2000).

Olson, Greg. "Plague on the Prairie." *Illinois Heritage* (January–February 2002).

Public Patron (May 1898). "Old Settlers Department." Springfield, Illinois literary magazine.

Shenk, Joshua Wolf. "Lincoln's Great Depression." *Atlantic Monthly* (October 2005).

Time magazine. "Education: Boys." March 12, 1934.

Van Cleave Blankmeyer, Helen. "Health Measures in Early Springfield: The First Half Century, 1818–1868." *Illinois State Historical Journal* (1951–52).

WEBSITES

Basler, Roy P., ed. *The Collected Works of Abraham Lincoln*. Vol. 1. Springfield, IL: Abraham Lincoln Association, 2006. http://quod.lib.umich.edu/l/lincoln.

Illinois Department of Agriculture. www.agr.state.il.us.

Illinois State Museum. www.museum.state.il.us.

Lincoln Home, National Park Service. www.cr.nps.gov/history/online_books/liho/sectiond-j.htm.

Papers of Abraham Lincoln. www.papersofabrahamlincoln.org.

The Statue of Liberty–Ellis Island Foundation, Inc. www.ellisisland.org.

U.S. Patents #1114167, 1438929, 1115710, 497347, 6910890 and 92897. www.google.com/patents.

ABOUT THE AUTHOR

Tara McClellan McAndrew is an award-winning writer in Springfield, Illinois, where her roots reach back at least five generations and include ties to Abraham Lincoln. One of her ancestors gave Lincoln land in Lincoln, Illinois, as repayment for a debt, and another, an attorney, opposed him in court. ("So one stiffed him and another provoked him at work," she says. "Should I be proud of this?")

Tara has written about local history since the 1980s. She currently writes a local history column for the central Illinois weekly newspaper, the *Illinois Times*. Before that, she wrote a weekly local history column for the Springfield daily paper, the *State Journal-Register*.

As a broadcast journalist, her work aired on National Public Radio, Illinois Public Radio and Christian Science MonitoRadio. Her articles have appeared in thirty-five publications, and her historical plays have been performed at various sites around Illinois.

Visit us at
www.historypress.net